IMAGES
of Aviation

DAYTON AVIATION
THE WRIGHT BROTHERS
TO McCOOK FIELD

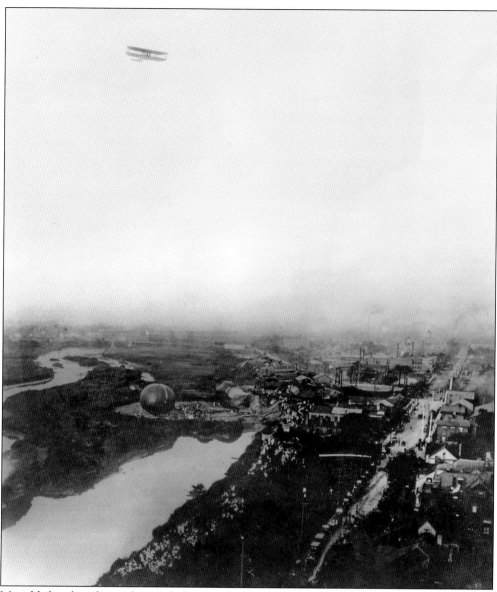

Most likely taken from a hot-air balloon, this photograph shows the 1910 Dayton Fall Festival from an altitude of 1,000 feet. On September 22, 1910, Orville Wright flew a Model B Flyer from the Huffman Prairie to downtown Dayton (a distance of nine miles). Orville circled above the festival and downtown Dayton for several minutes, drawing cheers from the crowd, before returning to the prairie. The hot-air balloon seen here is preparing to ascend from Buck Island. (Courtesy of US Air Force Photo Archives.)

ON THE COVER: Taken at South Field in Morain, Ohio, in early 1918, this image shows Orville Wright (left) and Dayton-Wright Company test pilot Howard Rinehart standing in front of a Dayton-Wright DH-4 Liberty Fighter just before one of Orville's last flights. The vibration of airplane engines aggravated injuries from Orville's 1908 crash, causing him to give up flying in May 1918. (Courtesy of US Air Force Photo Archives.)

IMAGES
of Aviation

DAYTON AVIATION
THE WRIGHT BROTHERS
TO McCOOK FIELD

Kenneth M. Keisel

ARCADIA
PUBLISHING

Published by Arcadia Publishing
Charleston, South Carolina

Printed in the United States of America

Library of Congress Control Number: 2012943635

For all general information, please contact Arcadia Publishing:
Telephone 843-853-2070
Fax 843-853-0044
E-mail sales@arcadiapublishing.com
For customer service and orders:
Toll-Free 1-888-313-2665

Visit us on the Internet at www.arcadiapublishing.com

*Dedicated to my father, Kenneth Gordon Keisel, and my
son Kenneth James Keisel, who never fail to inspire me*

CONTENTS

ACKNOWLEDGMENTS

As one might guess, it is no easy task to find photographs well over 100 years old. Fortunately, my work was made a joy by several people who shared my vision. First, I would like to thank my long-suffering assistant, Julian Halliday. My thanks also goes out to the following: Brett A. Stolle of the National Museum of the United States Air Force (NMUSAF) at Wright-Patterson Air Force Base in Dayton, Ohio, for providing me with images beyond my wildest expectations; Dr. Henry Narducci of the Air Space Command (ASC) History Office, who provided additional assistance and images; Dawne Dewey and Gino Pasi of Wright State University Special Collections, who made the chapter on The Wright Company possible; Don Willis and the WACO Air Museum; Jim Brown III, Janet Nystrom, and Hartzell Propeller Inc., as well as Jimmie A. Reedy, for making the Hartzell chapter possible; Hayden Hamilton and the American Aviation Historical Society, for their information on the Dayton-Wright Airplane Company; Dean Alexander, director of the Dayton area National Park Service, for his updates on the Wright Company factory buildings; and Jeff Ruetsche and Sandy Shalton at Arcadia Publishing. I would also like to thank Lois E. Walker, Shelby E. Wickam, Diana G. Cornelisse, Fred C. Fisk, and Mary Ann Johnson, whose books filled the wide gaps in my knowledge. Finally, I am grateful to the many gifted volunteers who donate so much time and energy at Dayton's many historical aviation sites. They keep the history of early aviation alive in Dayton.

Many of the photographs contained in this book are marked with Army Signal Corps identification numbers, left visible so that readers can look them up in The National Museum of the United States Air Force Photo Archives.

INTRODUCTION

Since the dawn of recorded history, people have looked to the skies with wonder, dreaming that they could fly. The earliest surviving story of human flight did not bode well for us. Greek mythology tells of Icarus and his father, Daedalus, who constructed wings to escape their imprisonment in the Minoan city of Knossos on the island of Crete. Icarus ignored his father's warnings. Lost in the joy of flight, he flew too close to the sun, melting his wings and sending him plummeting to his death. That story may be over 3,500 years old, but the quest for flight almost certainly dates back thousands of years before Icarus.

Today, in a world where distant cities are only an airline ticket away, it is difficult to imagine a time when flight was not a daily experience, yet that era, the era our great-grandparents shared with the ancient Greeks, is barely a century behind us. The quest for flight was finally achieved, not by Leonardo da Vinci, Isaac Newton, or a great Smithsonian scientist (though they all tried), but by two bicycle makers in Dayton, Ohio. Had the first airplane been built in New York City, Rome, or Berlin, it would have transformed that city. Had it been built by a world-famous inventor, it would have been his or her greatest achievement. That it came instead from Dayton, Ohio, and from the minds of two brothers with no formal education, is one of the great stories of modern times. Working in the back room of a bicycle shop during their off hours, they created the airplane, an invention that had eluded mankind for thousands of years. Orville and Wilbur Wright are just the start of the story that began in 1903 and is still continuing today.

If there are hallowed skies anywhere in the world, they must be over Dayton. The city has been called the "Cradle of Aviation" and with good cause. No other location on earth is so closely associated with the history of aviation or has made so large a contribution to the evolution of the airplane. Dayton gave the world its first airport and the first airplane factory. It gave the world crop dusting, landing lights, free-fall parachutes, guided missiles, private cabin airplanes, and strategic bombers. This book explores the great accomplishments of flight that have come out of Dayton. Through amazing photographs, it shows how the airplane evolved in the city and how the airplane, in turn, transformed Dayton into the National Aviation Heritage Area.

This book starts with the Wright brothers and concludes with the arrival of Wright and Patterson Fields in the 1930s. During those formative years, the airplane was evolving rapidly. Included in this book are chapters on the three original military airfields formerly located in the Dayton area: Wilbur Wright Field, McCook Field, and the Fairfield Air Depot. Wilbur Wright Field was a training base that turned out hundreds of pilots needed to fight in World War I. McCook Field was where the pilots' airplanes were developed and tested, while the Fairfield Air Depot provided logistical support to make sure those planes went where they were needed, along with the parts and supplies to keep them flying. Together, they made Dayton the epicenter of American military airpower.

Here too, is the story of America's earliest test pilots—men like Lt. Harold R. Harris and Lt. John A. Macready, who pushed the envelope of flight, taking us higher and farther than ever

before. On the civilian side, this book tells the story of the Wright brothers' business ventures following their first flights as well as chapters on the Dayton-Wright Aircraft Company, which produced 40 airplanes a day, and WACO Aircraft, once America's most successful small aircraft manufacturer. Finally, it describes a company called Hartzell Propeller. In 1917, Hartzell entered the fledgling business of manufacturing airplane propellers. Today, Hartzell Propeller Inc. is the world's largest turboprop propeller manufacturer.

The citizens of Dayton have much to be proud of, for from their city came an invention that has taken people to the far reaches of the earth and forever transformed the way we live.

One

It Was Invented in Dayton

Those who grew up in Dayton, Ohio, at the beginning of the 20th century would likely say it was no surprise the airplane was invented there. By 1900, Dayton listed more inventions than any other American city. The Wright brothers blended in this city of inventors, but quite unnoticed at first. The drive for innovation was fueled by Dayton's extensive manufacturing capacity. In 1900, Dayton already had a half-dozen automobile manufacturers, as well as factories for the production of sewing machines, agricultural equipment, and bicycles. The undisputed master of Dayton manufacturing was John H. Patterson's National Cash Register Company (NCR), commonly known as "the Cash," which was practically a patent factory. Though smaller than Cincinnati, Cleveland, or Columbus, Dayton was a glistening industrial jewel that took to calling itself the "Gem City."

By 1900, the airplane was one of the few predicted major innovations that still remained elusive. There can be little doubt that the brothers' printing and publishing business kept them keenly informed of the efforts of other inventors to produce a heavier-than-air flying machine. Designing their own brand of bicycle in 1896 gave them the practical experience needed to create a machine that could propel itself through the air and that could be safely controlled. The brothers' first US patent, 821,393, was for a system of aerodynamic control for the airplane's flight surfaces.

Neither of the two men had a high school diploma. Wilbur completed four years of high school, but the family moved before he received his diploma, while Orville left school after his third year to start a printing business. Despite this, the pair shared a strong belief that any problem could be overcome with the proper combination of research and testing. The brothers were problem solvers of the highest degree. In a city of inventors, Wilbur and Orville had the intelligence, determination, and resources to make the dream of flight a reality. No one would have dreamed the airplane would come from Dayton—except the people who lived there.

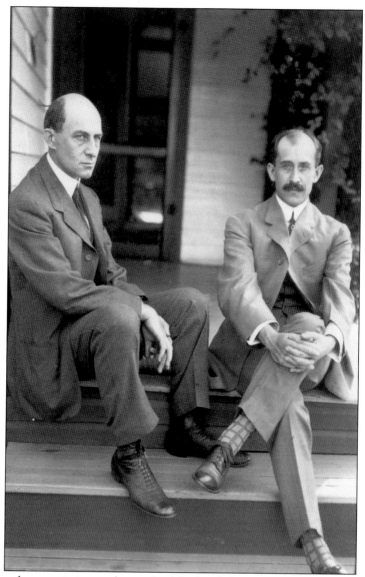

The Wright brothers are sitting on the porch of the family home at 7 Hawthorn Street in Dayton, Ohio. Wilbur (left) and Orville were two of seven children born to Milton Wright (1828–1917) and Susan Catherine Koerner (1831–1889). Wilbur was born near Millville, Indiana, in 1867, and Orville in this house in 1871. They were the middle children, with two older brothers, a younger sister named Katharine, and two younger twins who died in infancy. Their father was a bishop in the Church of the United Brethren in Christ. In 1878, he brought home a toy helicopter that Wilbur and Orville played with until it broke, so they then built their own. The brothers later cited that toy as sparking their interest in flying machines. A hockey injury caused Wilbur to abandon plans to study at Yale University. Eventually, he joined a printing business started by Orville. Older Wilbur was the ambitious one, driving younger Orville to pursue success, first with the bicycle shop they co-owned, then later with the airplane. Orville's talent was engineering. He possessed a natural ability to grasp the problems Wilbur put to him and come up with eloquent solutions. Wilbur and Orville built the house's covered wraparound porch in the 1890s. (Courtesy of Special Collections and Archives, Wright State University.)

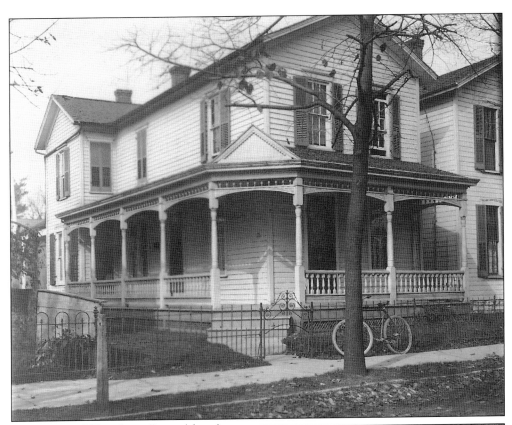

The home at 7 Hawthorn Street (above) was humble for a family of seven. The Wrights moved here in April 1871 and would remain in the house until moving to Hawthorn Hill, the Wright mansion, in 1914. Wilbur died of typhus in the upstairs front bedroom in 1912. The Wrights were an extremely close family. Over dinner, they would discuss the day's events, and Wilbur and Orville would describe their research and the designs for their airplane. Other family members would listen and comment. As a result, 7 Hawthorn Street should be considered the co-birthplace of the airplane, along with the bicycle shop where it was constructed. The c. 1900 photograph (at right) shows the family Christmas tree in the parlor. The brothers had just returned from their first experiments with gliders at Kitty Hawk, North Carolina. There was little to suggest that Wilbur and Orville were only three years away from changing the world. (Both courtesy of Special Collections and Archives, Wright State University.)

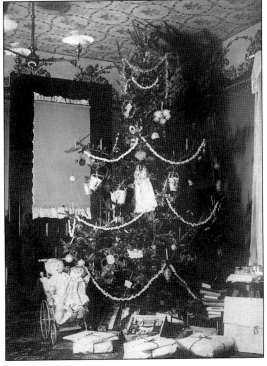

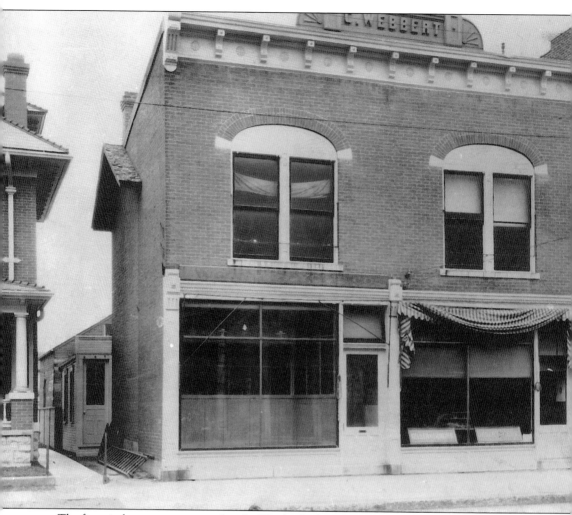

The first airplane was constructed at the Wright Cycle Company shop formerly located at 1127 West Third Street in Dayton. The building began as a two-story brick house; in 1897, two storefronts were added. The building was owned and named for Charles Webbert, owner of a plumbing business at 1121 West Third Street. In the fall of 1897, the Wright brothers moved into the left side of the building, while an undertaker worked in the right side. The Wrights manufactured their brand of bicycle, the Van Cleve, at the shop from 1897 until 1904. Though bicycle production ceased in 1904, the Wright Cycle Company remained in the shop until 1908. Employees repaired and sold bicycles, while the brothers ran their airplane business from the shop at the same time. Airplane production moved in 1911, but Orville maintained an office in the building until 1916. In 1936, the building was purchased by the Edison Institute and moved to Greenfield Village in Dearborn, Michigan. In 1951, a one-story drugstore was constructed on the site. It was razed around 2005, and the site is now a vacant lot containing a historical display. (Courtesy of Special Collections and Archives, Wright State University.)

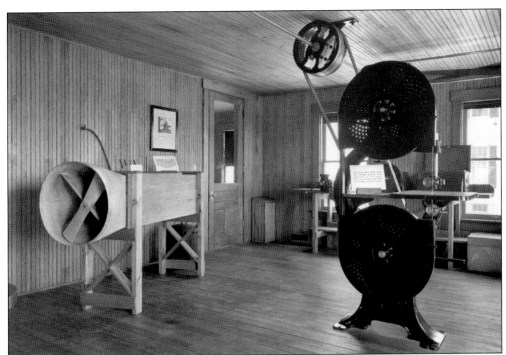

The machine shop (above), where Wilbur and Orville constructed the first airplane, was located in a wooden shed attached to the rear of the building. Here, the brothers constructed experimental gliders from 1900 until 1902, which they tested at Kitty Hawk, North Carolina. Their 1900 and 1901 Gliders were disappointments. By constructing a homemade wind tunnel to test their designs, they were able to discover that Otto Lilienthal's mathematical tables for air pressure and wing design were wrong. Conducting scientific experiments, the brothers were able to formulate their own tables from which they designed their successful 1902 Glider and 1903 Flyer—the world's first airplane. It was also in this shop that the first airplane engine and propellers were designed and constructed. A rare photograph (below) shows Wilbur Wright at work in the machine shop at the rear of 1127 West Third Street. Wilbur was a constant presence in the shop until his death in 1912. (Above, courtesy of Special Collections and Archives, Wright State University; below, US Air Force Photo Archives.)

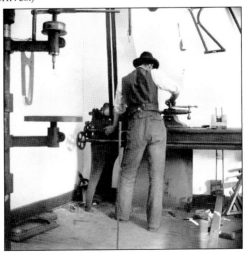

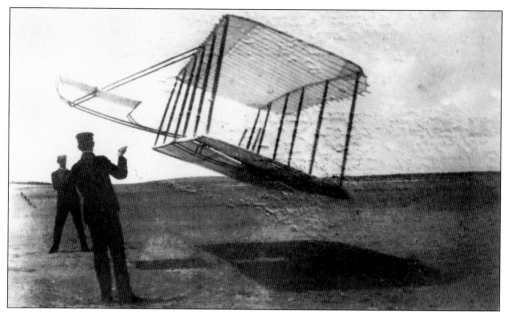

The 1901 Glider (above) is flown as a kite at Kill Devil Hill in Kitty Hawk, North Carolina, in August 1901. The brothers had traveled to Kitty Hawk to take advantage of the area's constant 20-mile-per-hour winds. The Wrights' 1900 and 1901 Gliders were similar; each had a flat wing with a single horizontal stabilizer mounted on the front. Despite having closely followed the aeronautical tables created by Otto Lilienthal, tests showed that this flat-wing design fell short of Lilienthal's predictions. The brothers quickly realized that Lilienthal's tables were wrong. (Courtesy of US Air Force Photo Archives.)

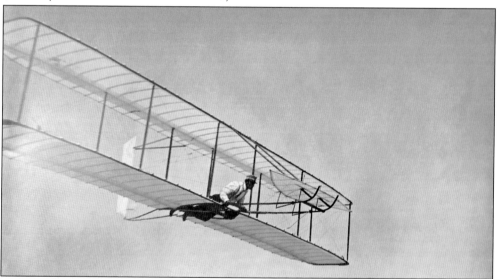

Wilbur Wright is flying the 1902 Glider at Kitty Hawk on October 10, 1902. Using their homemade wind tunnel, the Wrights developed a curved airfoil design that provided the lift needed for powered flight. Their 1902 Glider employed both a horizontal stabilizer in front and a vertical stabilizer at the rear. Moved by handles, the stabilizers gave the brothers the ability to control both pitch (up and down movement) and yaw (left to right movement). The glider was a success. All they needed now was an engine. (Courtesy of US Air Force Photo Archives.)

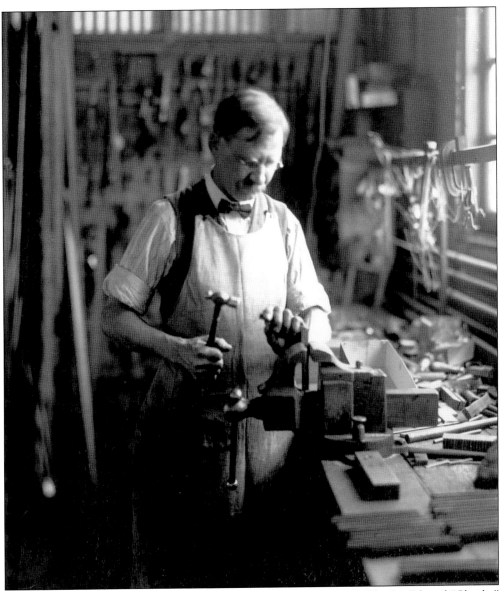

The job of constructing a motor for the 1903 Wright Flyer I went to Charles Edward "Charlie" Taylor (1868–1956). For several years, Taylor had been the Wrights' bicycle mechanic at their shop in Dayton. He had helped with the construction of their three gliders and the wind tunnel. It soon became clear to Wilbur and Orville that no engine existed light enough to produce the eight horsepower needed to propel their airplane. They gave rough sketches of a power plant to Taylor, who produced the water-cooled engine in only six weeks. He had the block and crankcase cast out of aluminum to save weight, and the finished block weighed only 152 pounds and produced 12 horsepower. Taylor worked for the Wright brothers until 1911, designing engines and traveling with them as chief mechanic for flying demonstrations. In 1909, he became chief mechanic for the Wright Company, the brother's airplane factory. He died in 1956 at age 87 and is buried at the Portal of Folded Wings Shrine to Aviation in Burbank, California. In 1965, Taylor was enshrined in the National Aviation Hall of Fame in Dayton. (Courtesy of Special Collections and Archives, Wright State University.)

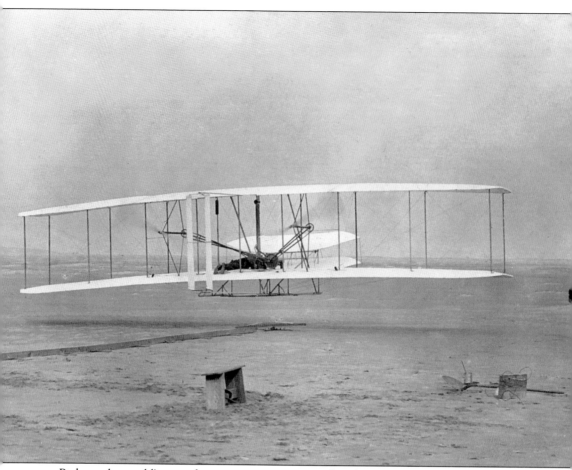

Perhaps the world's most famous aviation image, "the photograph of the century" shows the Wrights' first successful airplane flight. In November 1903, Wilbur and Orville returned to Kitty Hawk, North Carolina, with their new powered flying machine. They had spent months in Dayton assembling the wood frame and sewing muslin coverings using Katharine's sewing machine. The total cost was around $1,000, including shipping to Kitty Hawk—a large sum in 1903. On the morning of December 14, the pair flipped a coin to decide who would try first. Wilbur won, but after traveling down the launch rail, the Flyer dropped into the sand, causing minor damage. Following three days of repairs, on December 17 it was Orville's turn. Moments before boarding the plane, he focused the pair's camera at the end of the rail and handed the shutter release to John T. Daniels, one of several men from the Kill Devil Life Saving Station present to watch the event. At 10:35 a.m., Orville took off into a 21-mile-per-hour headwind. The Flyer practically leaped off the rail, traveling 120 feet in 12 seconds. Daniels snapped the shutter, producing this image. Orville and Wilbur would make four flights that day, each man flying twice. During the last flight at noon, Wilbur remained aloft for 59 seconds and traveled 852 feet. Shortly afterward, a strong wind flipped the Flyer over, causing serious damage. It would never fly again, but that scarcely mattered—for the first time in history a person had flown in a powered airplane. (Courtesy of Special Collections and Archives, Wright State University.)

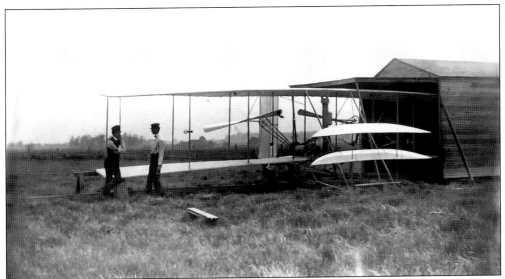

The Wright brothers returned to Dayton without fanfare. They had invented the airplane, but no one seemed to notice. They quickly filed for patents for their flyer design, as well as for the control systems they had developed. When they notified the Smithsonian Institution of their success, they were viewed with skepticism. In 1904, they constructed the Flyer II, which they took to Huffman Prairie, a 100-acre field located along the Dayton-Springfield-Urbana electric railroad line at Sims Station, eight miles east of Dayton. As a child, Orville had often traveled here for school trips to study the prairie's wildflowers. It later became the world's first airport. In 1904, the Wrights constructed a wooden hangar at Huffman Prairie to house their airplane (above). Lacking wind, they doubled the length of the launch rail to 120 feet and used a 1,400-pound falling weight to propel the flyer into the air. Away from prying eyes, they could fly their airplanes in great circles, perfecting their designs before marketing them to the world. The brothers took photographs of each flight. Flight No. 46 (below) occurred on October 4, 1905. (Both courtesy of US Air Force Photo Archives.)

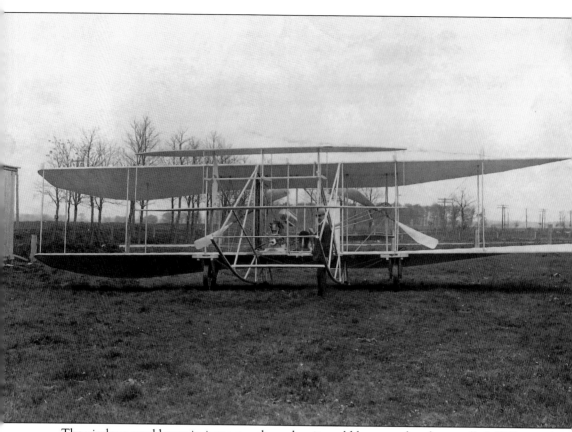

The airplane would remain just a novelty unless it could be steered and controlled. Wilbur and Orville knew this and developed a method of twisting the wings to change direction. Called "wing warping," Orville claimed Wilbur devised it by twisting a bicycle tube box. Cables connected the wings to a cradle that held the pilot. By shifting the body to the left or right, the pilot could twist the wings, causing the airplane to turn. The Wrights' patent was far-reaching, protecting not only wing warping but also other methods of control, such as ailerons. These patents gave the Wrights a virtual monopoly on aircraft production, collecting royalties from every airplane manufactured worldwide. The Wrights sued any aircraft manufacturer who refused to pay license fees, filing legal challenges across the United States and Europe. Their main rival was Glenn H. Curtiss, who founded the Curtiss Aeroplane and Motor Company in Buffalo, New York, in 1916. The patent wars lasted from 1908 until 1917. They slowed aircraft development in America, and likely cost Wilbur his life. Wilbur died of typhoid fever in 1912, which he contracted while attending a patent hearing in Boston. Wing warping was useless once metal wings were introduced in the 1920s. (Courtesy of US Air Force Photo Archives.)

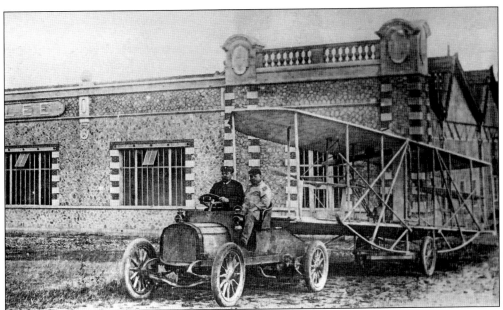

By 1908, the Wrights had been trying for three years to interest the US government in purchasing their airplanes. At the encouragement of the French government, the brothers decided that Wilbur would take a flyer to Europe in hopes of finding customers there. This photograph shows the flyer arriving at Hunadieres Race Course, just south of Le Mans, on August 8, 1908. The French already had an airplane capable of short hops along a straight line and expected no better from the Wright Flyer. (Courtesy of US Air Force Photo Archives.)

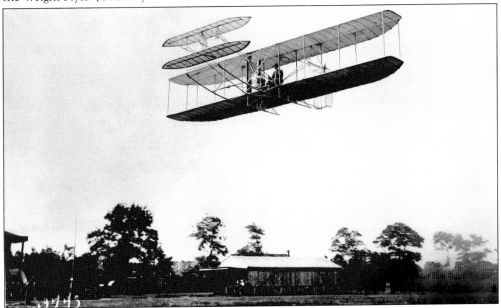

Wilbur demonstrated the flyer by making sweeping turns and staying aloft for an hour or more, first over the French racecourse at Hunadieres and then at Camp D' Auvours artillery grounds. By 1908, the Wright Flyer could travel 125 miles at 40 miles per hour. French aviators were stunned by the Wrights' machine; their own aircraft could only travel less than a mile and could not turn. (Courtesy of US Air Force Photo Archives.)

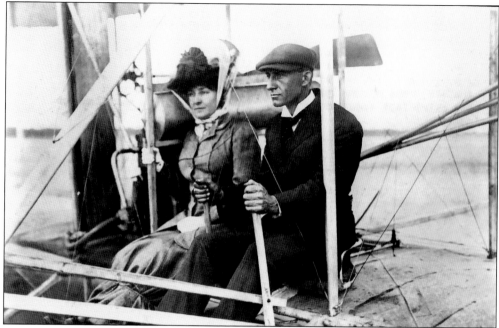

Taken only minutes before Wilbur made history on October 7, 1908, this photograph shows the first woman to fly. The world's first aviatrix was Edith Berg, wife of Hart O. Berg, the Wright brother's French publicist. Edith insisted that Wilbur take her for a flight. He objected, noting that her long skirt could blow up around her. Undeterred, Edith Berg tied a cord around her skirt. Wilbur then obliged, taking her to an altitude of 30 feet for two and a half minutes. (Courtesy of US Air Force Photo Archives.)

On September 26, 1908, Wilbur Wright flew for an hour and 18 minutes over Camp D' Auvours artillery grounds about 10 miles east of Le Mans. Wilbur's endurance flights shocked French aviators, who were accustomed to flights only a few seconds long. Word of the Wrights' machine soon reached the royal courts of Europe. (Courtesy of US Air Force Photo Archives.)

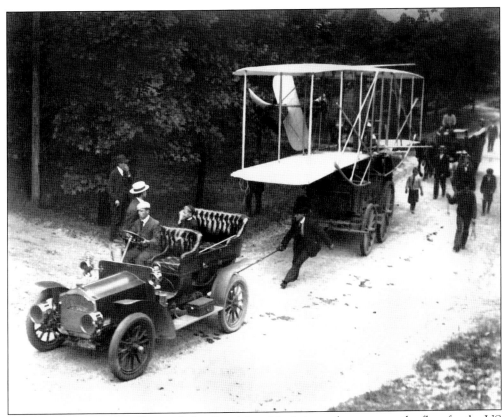

In September 1908, Orville traveled to Fort Myer, Virginia, to demonstrate the flyer for the US Army Signal Corps. On February 8, 1908, the US War Department accepted a $25,000 bid from the Wrights for a flyer capable of traveling at 40 miles per hour for 125 miles with two passengers. The flyer arrived at Fort Myer on a trailer pulled by a 1907 Lozier Model I Touring Car. Orville is standing on the running board. (Courtesy of US Air Force Photo Archives.)

Orville Wright (right) is seen with 1st Lt. Thomas E. Selfridge on September 17, 1908. Lieutenant Selfridge was the US Army's only pilot, having soloed in the Aerial Experiment Association airplane *White Wing* the previous May. He was to be the Army's acceptance pilot for the Wright Flyer. The day's first flight was supposed be made by Orville and Charlie Taylor, the Wrights' mechanic, but Selfridge needed to leave and replaced Taylor as passenger. (Courtesy of US Air Force Photo Archives.)

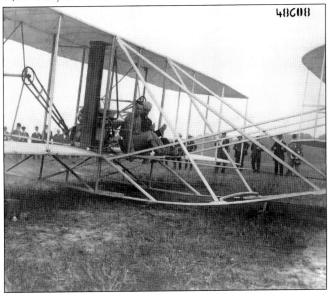

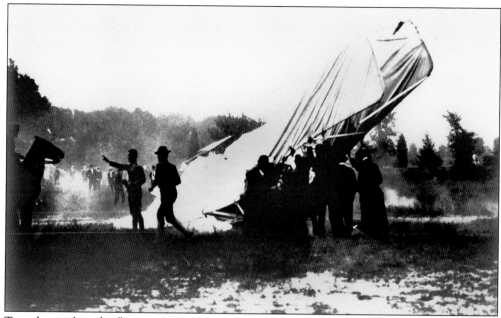

Tragedy struck as the flyer was beginning its fourth circle around the field. One hundred feet off the ground, the airplane's starboard propeller broke apart, cutting the airplane's tail wires. Out of control, the flyer plummeted to the ground. Charlie Taylor was first to the scene, pulling Orville and Lieutenant Selfridge from the wreckage. They were rushed to the hospital: Orville had suffered a dislocated hip, broken leg, several broken ribs, and back injuries; Lieutenant Selfridge (below, on the stretcher) suffered a fractured skull. He underwent surgery but died the next day. Orville wept upon hearing the news. Lieutenant Selfridge was the world's first airplane crash fatality. In 1917, the Army dedicated Selfridge Field in Mount Clemens, Michigan, in his honor. (Both courtesy of US Air Force Photo Archives.)

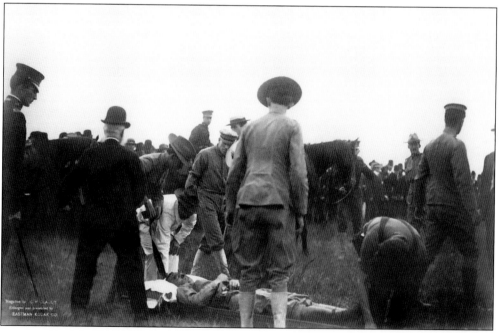

While Orville was recovering from his injuries, Wilbur remained in France, giving demonstrations and seeking customers. On February 20, 1909, the airfield was visited by King Alphonso XIII of Spain (in the suit and hat). The normally regal king became almost childlike with enthusiasm over the Wright Flyer and eagerly questioned Wilbur about it. Within minutes, he was in the passenger seat, learning the controls from Wilbur, who was taken by the king's enthusiasm. King Alphonso then announced that he would go up with Wilbur. The news shocked both the king's advisers and his wife, Queen Victoria Eugenie. It took considerable coaxing by Queen Ena to convince him not to fly. (Both courtesy of US Air Force Photo Archives.)

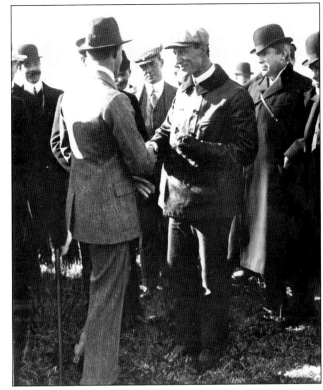

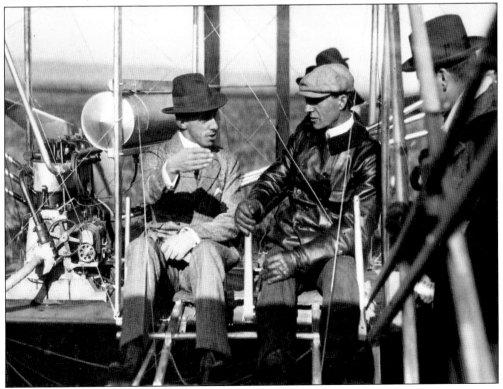

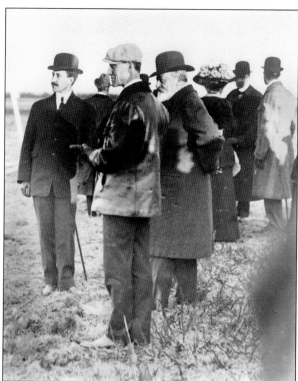

In January 1909, Orville and Katharine left Germany to join Wilbur at Pau, France. From left to right are Orville, Wilbur, and King Edward VII of England. (Courtesy of US Air Force Photo Archives.)

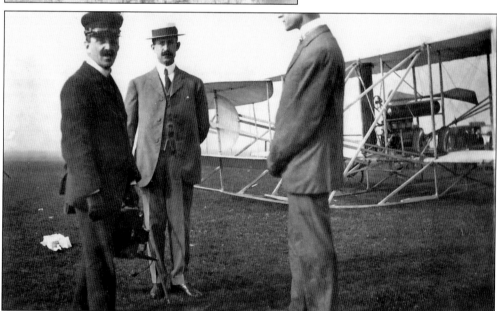

King Victor Emmanuel III of Italy, seen holding a camera at left, was another visitor to the French airfield in 1909. With the threat of war looming across Europe, the Wrights' airplane drew much interest from the military leaders of France, Britain, Germany, and Italy. Though the US War Department had ignored the Wrights for three years, there is little doubt that European designers were developing improved versions of the Wright Flyer even before the brothers had left Europe. (Courtesy of US Air Force Photo Archives.)

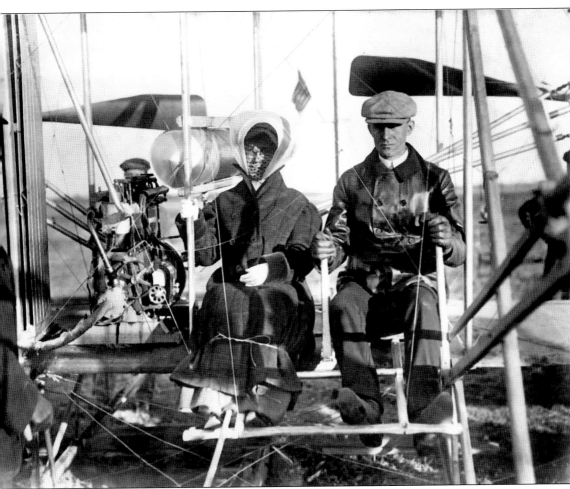

By 1909, Wilbur and Orville were celebrities all across Europe, though it was their sister Katharine who attracted the most attention. More outgoing and charming than her two reserved brothers, Katharine wowed the press. Born on Orville's third birthday, she was especially close to Wilbur and Orville. When their mother died in 1889, Katharine assumed responsibility for the household. Upon learning of Orville's crash in September 1908, Katharine took emergency leave from her teaching position in Dayton to be at his bedside. During Orville's seven-week recovery, Katharine rarely left his room. On March 15, 1909, Wilbur took her on her first flight at Pau, France (pictured). Though she did not help invent the airplane, Katharine is often considered the third Wright brother. (Courtesy of US Air Force Photo Archives.)

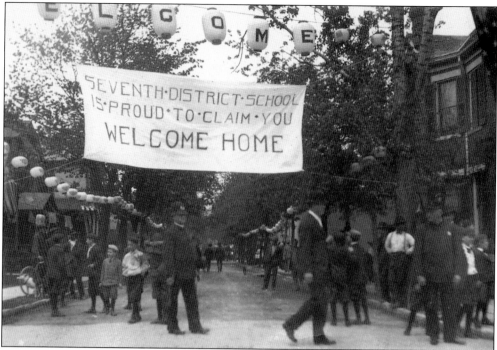

Wilbur, Orville, and Katharine returned to Dayton on May 13, 1909, having made headlines across Europe. Now, it was Dayton's turn to honor its own. Arriving at 12:05 p.m. at Dayton's Union Station, the trio was greeted with a carriage drawn by four white horses. Ten other carriages made the procession through Dayton to Hawthorn Street, while thousands of Dayton residents lined the streets to welcome the Wrights home. Orville's former school had decorated Hawthorn Street and the family home with garlands and lanterns (above). That evening, Katharine gave a speech from the porch of 7 Hawthorn Street (below), thanking the citizens of Dayton for their hospitality. (Both courtesy of Special Collections and Archives, Wright State University.)

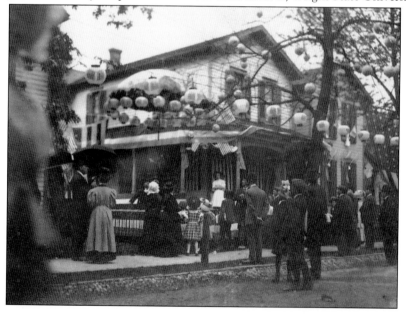

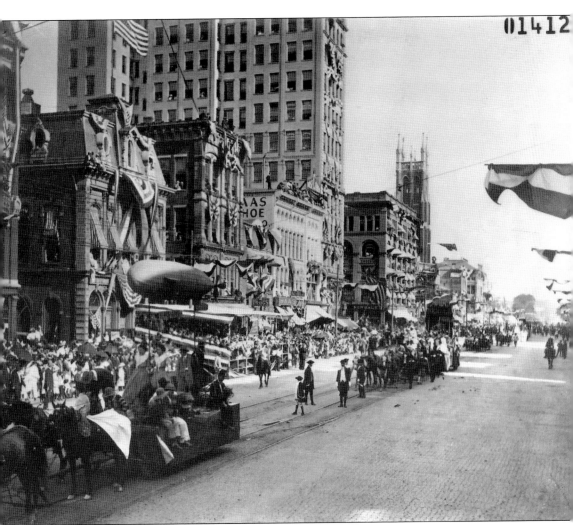

Dayton declared June 17 and 18, 1909, the Wright Brothers Home Celebration: two full days of honoring and celebrating the Wright brothers and their invention, the airplane. Thursday, June 17, was a day of awards and speeches held in Van Cleve Park followed by a human flag made up of 2,500 Dayton schoolchildren. That evening, a spectacular fireworks display was held along the Miami River. June 18 was highlighted by a grand parade through downtown Dayton. The parade began at 2:30 p.m. on Second Street, wound around St. Clair, First, Jefferson, Fifth, Main, Monument, and Ludlow Streets, and concluded back on Fifth Street. Thousands of people lined the streets to see state and federal troops march by, followed by 16 floats depicting the history of transportation. It was the largest event in Dayton's history, surpassed only by the 2003 Centennial of Flight celebration commemorating the 100th anniversary of the Wright brother's 1903 flight. (Courtesy of US Air Force Photo Archives.)

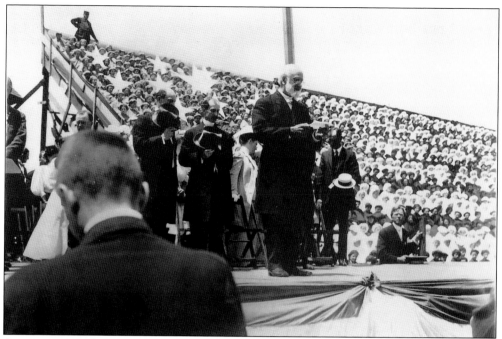

A presentation of national, state, and city medals to Wilbur and Orville was held at 10:30 a.m. on June 18, 1909, at the Montgomery County Fairgrounds. A crowd estimated at 75,000 filled the stadium to witness the event. The ceremony started with a rare appearance by the brothers' father, Bishop Milton Wright, who gave the opening invocation. Wilbur and Orville can be seen standing on the left. (Courtesy of US Air Force Photo Archives.)

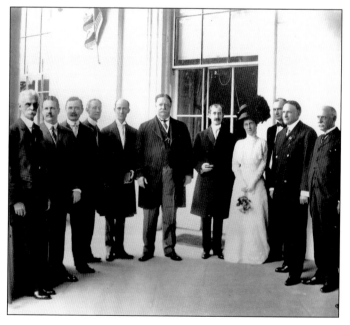

A week earlier, at 2:30 p.m. on June 10, 1909, Pres. William Howard Taft (center) presented Wilbur and Orville with Aero Club of America medals in the East Room of the White House. Katharine was also present for the event. Taft, a fellow Ohioan, was particularly pleased that the airplane had been invented in his home state. The medals were conceived by Victor D. Brenner, designer of the Lincoln penny. They are now on permanent display at the Wright State University Library in Dayton. (Courtesy of US Air Force Photo Archives.)

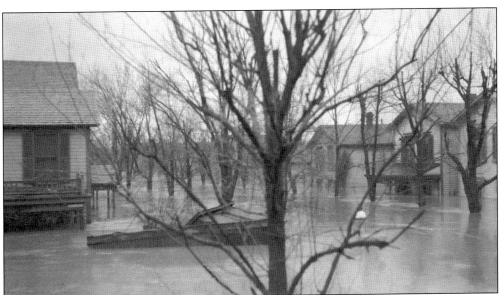

This photograph (above) shows Hawthorn Street as it appeared on March 26 during the Great Dayton Flood of 1913. The Wright brothers' home at 7 Hawthorn Street is visible at right, its wraparound porch just barely above the waterline. The flood was the worst in Dayton's history, killing 123 people and 1,450 horses. The Wrights' new mansion in Oakwood was still under construction at the time. Orville, Katharine, and their father, Milton, were forced from their home, which was badly damaged. Worse, the original glass negatives for their Kitty Hawk photographs, including the photograph of the first flight, were stored in the basement of the home. The glass plates were submerged for nearly two weeks, damaging or destroying many of them (below). They are now safely stored in the National Archives in Washington, DC. (Above, courtesy of Special Collections and Archives, Wright State University; below, US Air Force Photo Archives.)

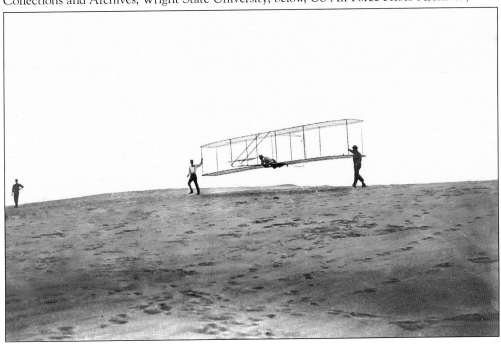

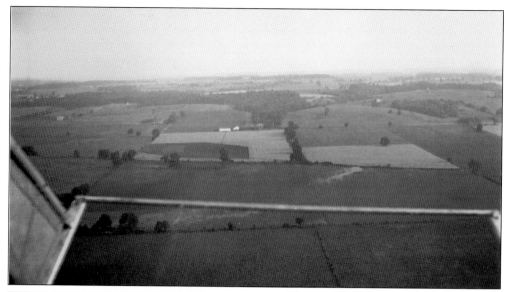

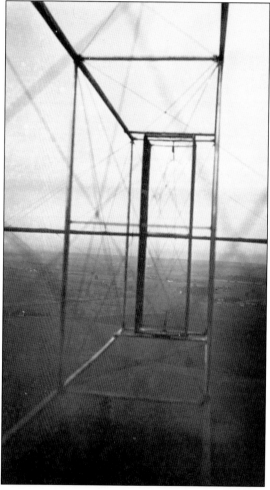

These c. 1910 photographs were taken from a Wright B Flyer over the Huffman Prairie and are among the world's earliest aerial images. With no cockpit or enclosed cabin, the pilot and passenger have a virtual 360-degree view of the countryside below them. The view to the front is above and the view to the rear of the craft is at left. Views such as these can still be seen today, as the nonprofit organization Wright B Flyers, Inc. regularly flies two replica Wright B Flyers from its hangar museum at Dayton-Wright Brothers Airport in Dayton, Ohio. (Both courtesy of Special Collections and Archives, Wright State University.)

Two

THE WRIGHT COMPANY

Having finally secured a military contract, the Wright Company was incorporated on November 22, 1909; Wilbur was president and Orville was one of two vice presidents. The brothers received $30,000 from the US Army for the first military flyer and $400,000 from a group of shareholders. At first, the Wright Company occupied a rented corner of the Speedwell Automobile plant on Essex Avenue in Dayton. In November 1910, the company moved to its permanent home on the south side of West Third Street along Coleman Avenue, about a mile and a half west of the bicycle shop.

In May 1912, Wilbur Wright died of typhoid fever. Orville became the president of the company but soon discovered running a business was not to his liking. After buying out the other stockholders, in October 1915 he sold the Wright Company and all of its patents to a group of investors, who merged it with the Glenn L. Martin Company a year later, forming the Wright-Martin Aircraft Company. In March 1917, it closed the Dayton factory, moving the operation out of town. In 1919, the company reorganized as the Wright Aeronautical Corporation and began building the Wright Whirlwind, a highly successful air-cooled radial engine. In 1929, the company merged with the Wright brothers' former rival, the Curtiss Aeroplane Company, forming the Curtiss-Wright Company. By this point, neither Orville nor Glenn Curtiss had any connection with the companies that bore their names.

The photographs in this chapter include virtually every surviving image of the Wright Company. This book represents the first time these photographs have all been printed together in one volume.

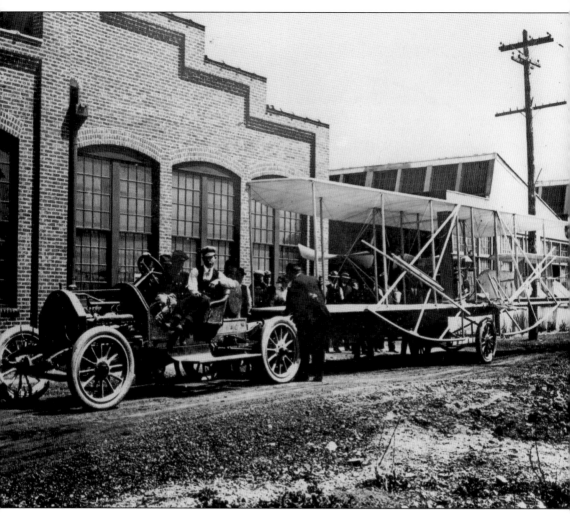

The first Wright Company site—the world's first airplane factory—was in a rented corner of the Speedwell Automobile plant on Essex Avenue (now Wisconsin Boulevard). This location is now a vacant lot at the southeast corner of Wisconsin Boulevard and Miami Chapel Road. The Wright Company occupied the Speedwell plant from February 1910 until November 1910. The flyer's engines continued to be built at the bicycle shop on West Third Street. The Speedwell site produced the Model B Flyer, the world's first mass-produced airplane, and the Model R, a single-seat racing version of the Model B. This c. 1910 photograph shows a completed Model B Flyer on a trailer at the Speedwell factory on Essex Avenue. The Flyer is on its way to Huffman Prairie for a test flight. (Courtesy of Special Collections and Archives, Wright State University.)

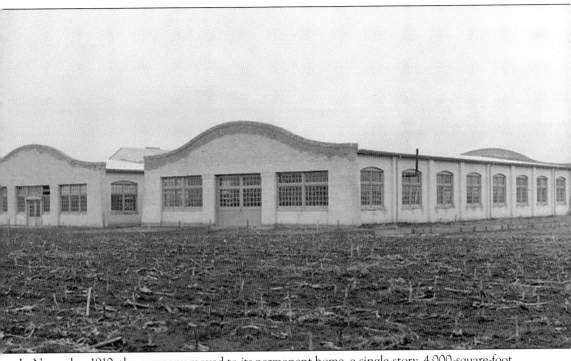

In November 1910, the company moved to its permanent home, a single-story, 4,000-square-foot building designed to resembled a hangar. The first building (left) was constructed in a cornfield on the south side of West Third Street along Coleman Avenue a mile and a half west of the bicycle shop. In 1911, a second identical building (right) was constructed alongside it. The additional building made it possible to produce four airplanes a month, the largest output of any aircraft manufacturer of the time. Between 1910 and 1915, the Wright Company produced a steady stream of both civilian and military aircraft. The company's four- and six-cylinder engines were also produced at the factory, ending aircraft production at the bicycle shop. Though actual production figures are speculative, it is believed Wilbur and Orville manufactured less than 100 bicycles but more than 200 airplanes. (Courtesy of US Air Force Photo Archives.)

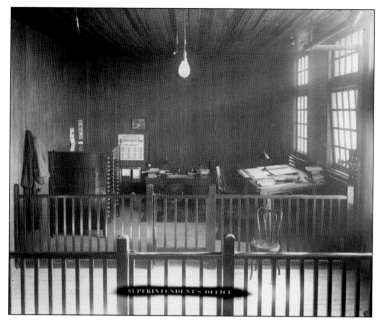

The front door of the factory is in the center right of this 1911 photograph. As one entered the factory, a center aisle led past two offices to the assembly floor. The superintendent's office was to the right, as seen here. The room had wood-paneled walls and ceiling, and a single exposed electric lightbulb hung from the ceiling above the aisle. (Courtesy of Special Collections and Archives, Wright State University.)

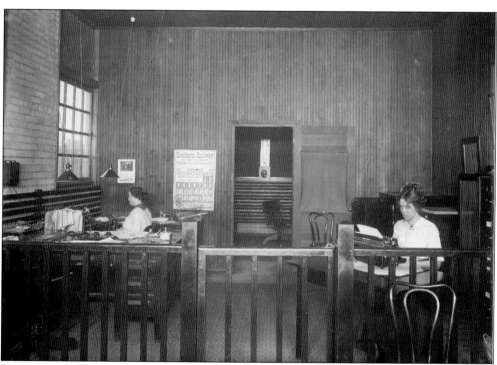

To the left of the center aisle was the secretary's office, seen in this 1911 photograph. Note the absence of telephones. The secretary's job was to open and respond to incoming mail, type letters, and organize files. In 1911, the Dayton Post Office made two deliveries a day. The arrival of the telephone moved business communication from letters to phone calls, though it did not become widely used in Dayton until after 1915. Wilbur's office is beyond the door at the rear. (Courtesy of Special Collections and Archives, Wright State University.)

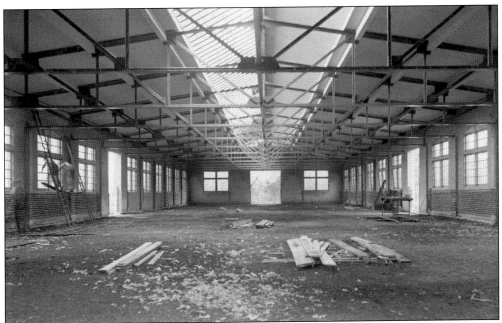

The interior of the newly completed first factory building is seen under construction in September 1910 just before the Wright Company moved in. Each building had 4,000 square feet of assembly and office space. A second building was constructed next to the first in 1911. (Courtesy of Special Collections and Archives, Wright State University.)

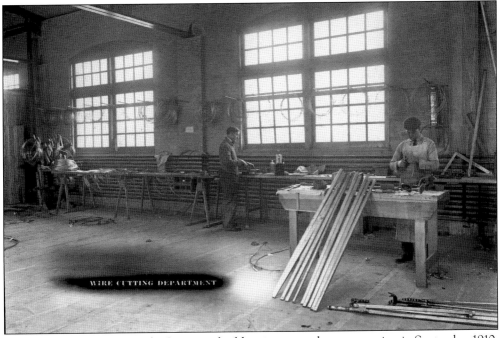

WIRE CUTTING DEPARTMENT

The interior of the first Wright Company building is seen under construction in September 1910. Employees Frank M. Quinn (left) and James Davis (right) are cutting bracing wires for wings and control wires for warping wing surfaces. (Courtesy of Special Collections and Archives, Wright State University.)

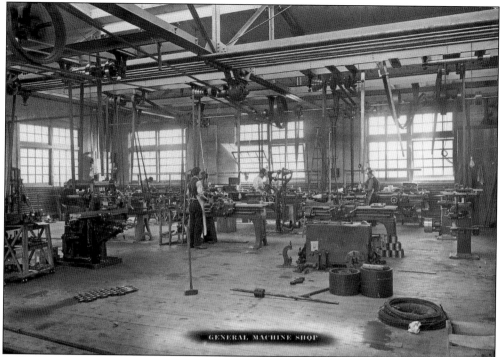

In the first building of the General Machine Shop, all the machines were powered by belts connected to a few overhead driveshafts. Note that there was virtually no overhead electric lighting; the building was illuminated by skylights. Tom Russel is working in the Machine Shop in the c. 1911 photograph below. (Both courtesy of Special Collections and Archives, Wright State University.)

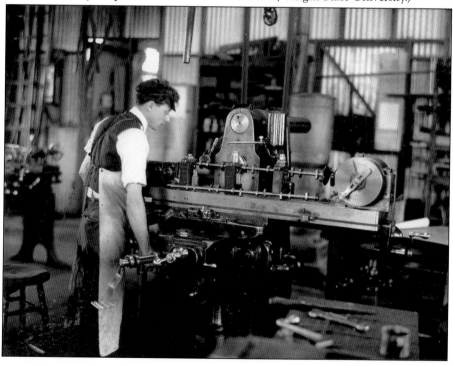

The Metal Fitting and Motor Assembly Shop was located alongside the General Machine Shop in the first building's rear. Here, the flyer's engines were assembled. In 1911, airplane production was still a cottage industry. Each engine was hand built by one or two employees, usually Charlie Taylor. The Wright Company could produce only about four engines a month. (Courtesy of Special Collections and Archives, Wright State University.)

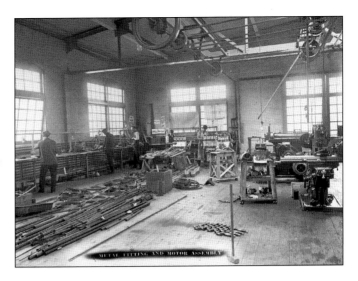

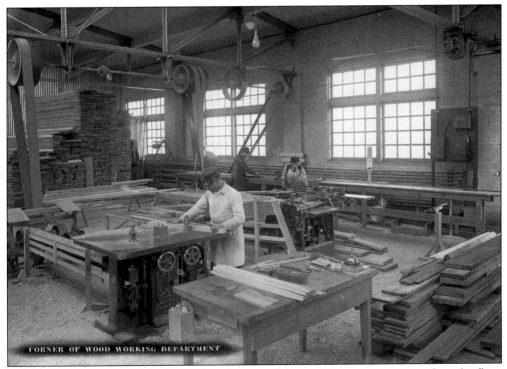

The Wood Working Department produced many of the wooden components used on the flyer. Ash and spruce were used to build the machines. In this c. 1911 photograph, employees Dan Farrell, Frank M. Quinn, and Bill Conouer are seen transforming stacks of dried lumber into the narrow spars used to form the flyer's frame. (Courtesy of Special Collections and Archives, Wright State University.)

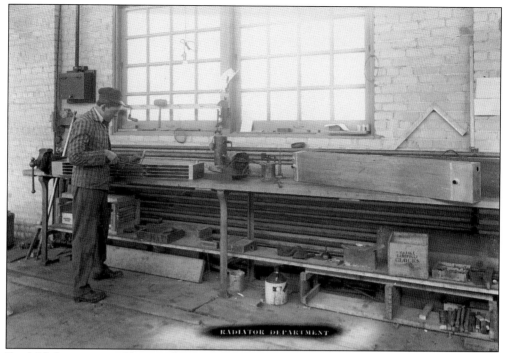

Frank M. Quinn is assembling a radiator for a Wright Model B Flyer in 1911. The Wrights' four- and six-cylinder engines were all water cooled, requiring a radiator that was mounted upright between the wings near the engine. (Courtesy of Special Collections and Archives, Wright State University.)

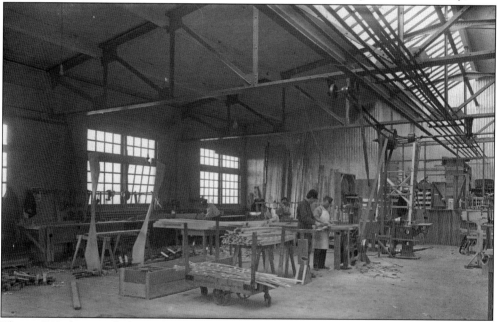

This c. 1911 photograph shows the Propeller and Rib Department. On the left are two completed propellers for a Model B Flyer; each has been honed down from a single board using a handheld plane. Many early airplane manufacturers hired furniture makers for jobs like this because of their woodworking experience. (Courtesy of Special Collections and Archives, Wright State University.)

Ida Holdgreve is sewing wing coverings in a corner of the Sewing Department in this c. 1911 photograph. Women generally performed fabric cutting and sewing duties. During World War II the US military employed civilian women at training air bases to sew and repair fabric-covered Stearman and Yellow Pearl trainers. (Courtesy of Special Collections and Archives, Wright State University.)

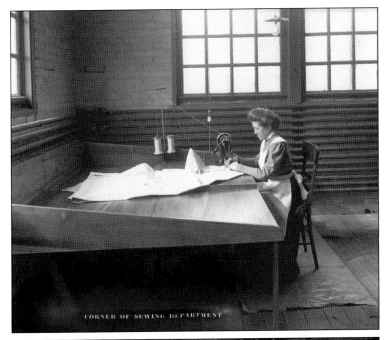

CORNER OF SEWING DEPARTMENT

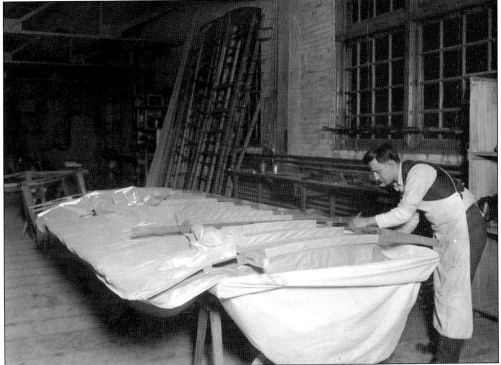

C.P. Nellis is fitting fabric to a flyer's wing in this c. 1911 photograph. The fabric was an unbleached muslin called "Pride of the West." Designed for women's undergarments, its thickness did not allow air to pass through, which would have caused drag. It is unclear if the Wright brothers were aware of this when they selected it for their original 1903 Flyer since it was also inexpensive and readily available. (Courtesy of Special Collections and Archives, Wright State University.)

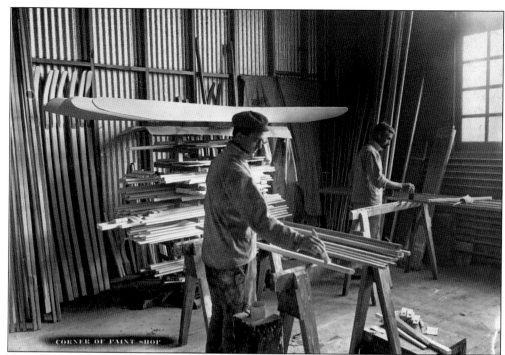

CORNER OF PAINT SHOP

In the corner of the Paint Shop seen above, W. Steinway (left) and Harry Harold apply paint or varnish to wood-frame spars. Wood components were produced in quantity and then stored in the Paint Shop. Most wood parts of a Wright Flyer were coated with aluminum powder, not painted, to prevent moisture from warping the wood. Harry Harold is seen below painting a propeller around 1911. Wright propellers were always painted silver to give the illusion they were made of metal. Several original Wright propellers can be seen on display in the Wright State University Library Special Collections in Dayton. (Both courtesy of Special Collections and Archives, Wright State University.)

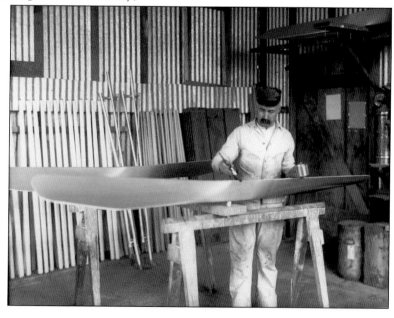

James Arnold is fitting wire bracing to the rudder of a Wright B Flyer in the General Assembly Department in this c. 1911 photograph. Wilbur and Orville often walked around the factory performing quality checks, and the flyer's wire bracing was an area they paid close attention to. Loose bracing could cause a flyer to come apart in the air and cost a pilot his life. (Courtesy of Special Collections and Archives, Wright State University.)

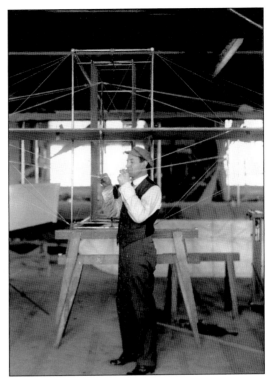

Mechanic Albert M. Flora performs the final assembly on the wing of a Wright B Flyer in the General Assembly Department in this c. 1911 photograph. Four flyers are visible awaiting engines. The motor was added during the final assembly and constituted about $1,600 of a Model B Flyer's $5,000 price tag—at a time when the average American was earning $750 a year. By 1918, the price of a new Dayton-Wright DH-4 had risen to $11,250. (Courtesy of Special Collections and Archives, Wright State University.)

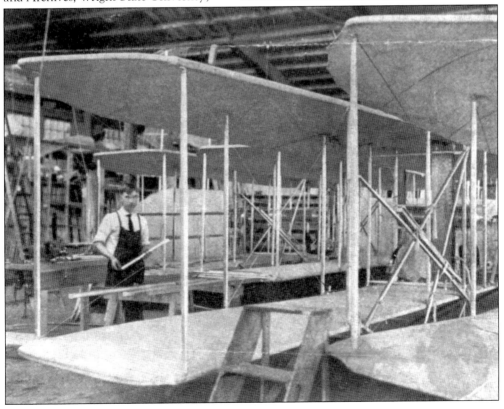

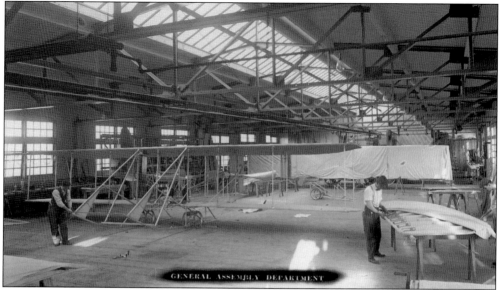

A Wright Model B Flyer is being completed in the General Assembly Area in this early 1911 photograph. The Model B was the world's first mass-produced airplane and the first one built by The Wright Company. It differed from the Model A because the elevator was on the tail rather than at the front. In December 1911, a modified Model B, named the *Vin Fiz Flyer*, became the first airplane to fly across the United States. (Courtesy of Special Collections and Archives, Wright State University.)

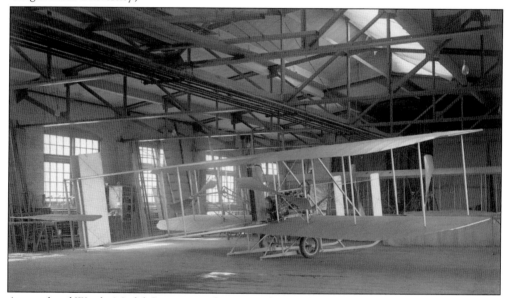

A completed Wright Model C is seen in the General Assembly Area in 1912. The Model C Speed Scout was designed exclusively for the US Army Signal Corps. It used the Wrights' first in-line six-cylinder engine and could remain aloft for four hours. Eight machines were built, but six were involved in fatal crashes, causing the type to be withdrawn after only two years in service. Wright Flyers were dangerous aircraft; among many faults, they were unable to pull out of dives steeper than 40 degrees. More than half of all Wright test and exhibition pilots were killed in crashes. (Courtesy of Special Collections and Archives, Wright State University.)

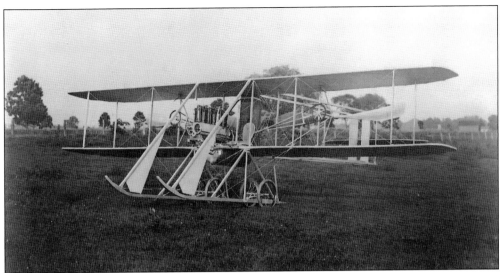

A Wright Model D Flyer is seen at Huffman Prairie in 1912. The Model D Speed Scout used a 406-cubic-inch, in-line six-cylinder engine and could reach 66 miles per hour. Orville called the Model D "the easiest to control of any we have ever built," but the Army disliked its high landing speed, and only two were built. The Model D was the last airplane designed with Wilbur's assistance. He died in November 1912. (Courtesy of US Air Force Photo Archives.)

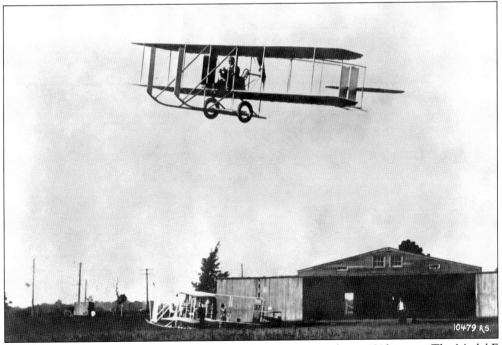

The sole Model E is flying over the Wright brothers' hangar in this c. 1913 image. The Model E was the first Wright Flyer with a single-pusher propeller. It used two 24-inch wheels, another first for a Wright aircraft. The Model E was the first airplane in history fitted with an autopilot. On December 31, 1913, Orville Wright demonstrated the automatic stabilizer by flying seven circles around Huffman Prairie with his hands over his head, earning him the 1913 Collier Trophy from the Aero Club of America. (Courtesy of US Air Force Photo Archives.)

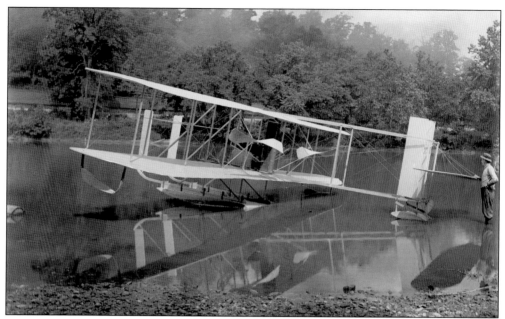

The Model CH was the Wright Company's first hydroplane. It is seen during test trials on the Great Miami River between June 27 and July 2, 1913. Two Model CH machines were built. They were both modified Model C Flyers: one had twin floats under the wings and a single smaller float under the tail, and the other used just a single float. The Wright hydroplane site was a stretch of the Great Miami River that extended from just south of the Sellers Road Bridge to the Light Company's former Frank M. Tait Station. Orville made over 100 flights in the Model CH from this site in 1913. (Courtesy of Special Collections and Archives, Wright State University.)

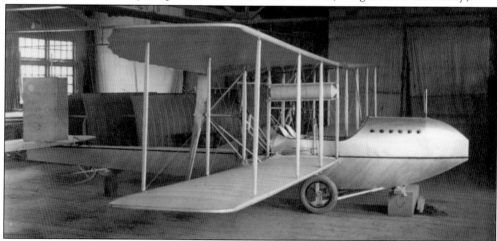

The Model F, seen in the Wright Company Assembly Department in 1914, was a significant departure from previous flyers. It was the first Wright airplane to feature a canvas-covered fuselage and a conventional tail. The Model F had an in-line six-cylinder engine in the nose with a driveshaft running between the two seats to a chain in the rear that turned two propellers. The wings had a pronounced dihedral to increase lateral stability. By 1914, European aircraft manufacturers had moved the propeller to the nose. Orville was reluctant to move the propellers to the front for fear it would hurt his patent suit against Glenn H. Curtiss. (Courtesy of Special Collections and Archives, Wright State University.)

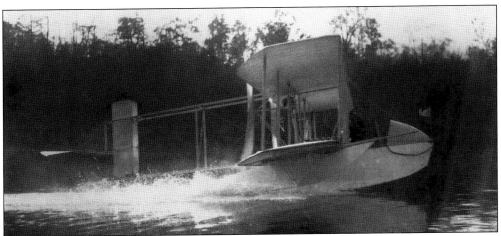

The prototype Model G Aeroboat is seen taking off on the Great Miami River on November 13, 1913. It was designed by Grover Loening under the supervision of Orville Wright. Following Wilbur's death, Loening became the designer for the Wright Company. He left in 1914 to become chief aeronautical engineer for the U.S. Army's Aviation Section in San Diego. In 1917, he formed the Loening Aeronautical Engineering Corporation. Only two Model G Flyers were produced, and they were the Wright Company's only flying boats. The second Model G moved the elevator to the top of the tail, creating a T-tail. (Courtesy of Special Collections and Archives, Wright State University.)

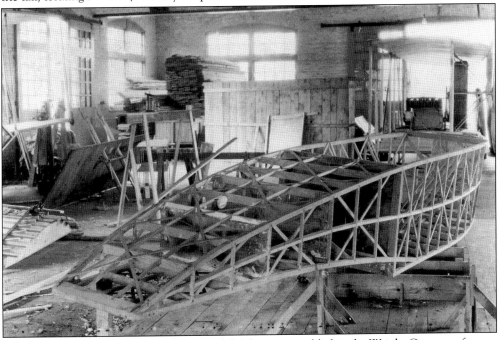

This very unusual photograph shows a Model G being assembled in the Wright Company factory in late 1913. The Model G was constructed of a wooden frame covered with molded wood panels made from ash and spruce coated with aluminum. The wings, tail, and propeller formed a single unit attached to the rear of the fuselage from the top that could be removed for transport. Throughout its existence, the Wright Company developed only two new models a year. Though innovative, models like the F and G were putting the company well behind competitors like Curtiss and Martin. (Courtesy of Special Collections and Archives, Wright State University.)

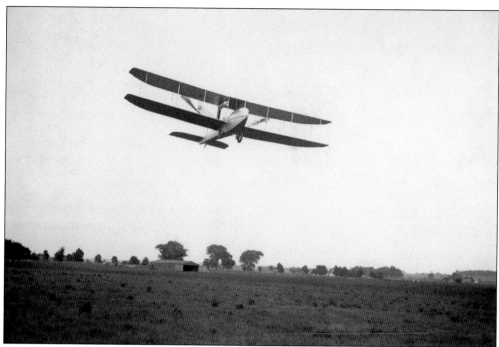

The 1914 Model H (above) and 1915 Model HS (below) were the final evolution of the Model F and the company's last pusher aircraft. They resembled the Model F but had a more streamlined fuselage that tapered at the tail to reduce drag. With 38-foot wings, the two-seat Model H could carry a 1,000-pound load, while the Model HS had a short, 32-foot wingspan to increase speed and rate of climb. Both machines had side-by-side seating, but unlike the Model F both seats had controls. They were designed as military scout aircraft. In 1915, Dayton pilot Howard Reinhart purchased a Model HS, which he delivered to Pancho Villa. Reinhart flew it as part of Villa's insurgent force before joining the Dayton-Wright Company in 1917. (Both courtesy of Special Collections and Archives, Wright State University.)

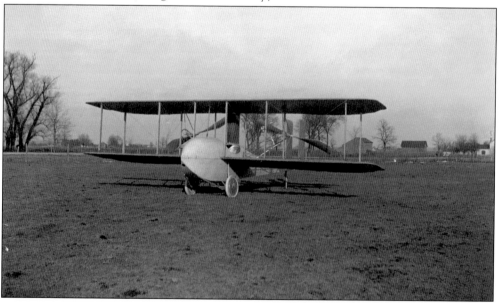

Orville sold the Wright Company in 1915. In 1916, the new owners introduced Models K and L. Though similar, the Model K had floats. Designed as a Navy scout plane (Model L was designed for the Army), it used two chain-driven propellers mounted on the wings in a forward-facing tractor arrangement, a company first. The Model L (above) was the company's first airplane with a conventional front engine/propeller design. Hopelessly inferior to European aircraft, Models K and L would have been easy targets for the German Fokker and Albatross had they seen action in World War I. Only one prototype of each was built. The single-seat Model L used a steering wheel (at right) designed by woodworking supervisor Harvey D. Geyer. In 1923, General Motor's Inland Manufacturing Company moved into the original Wright factory buildings, where they continued producing this iron and wood steering wheel for use in automobiles. (Both courtesy of Special Collections and Archives, Wright State University.)

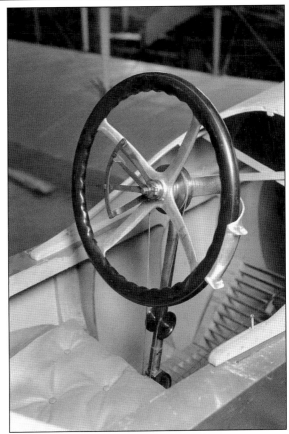

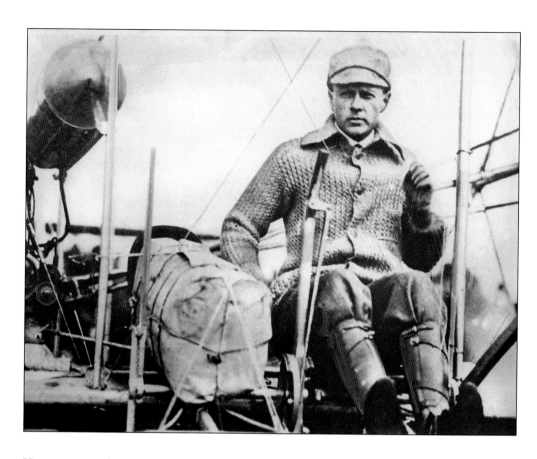

History was made on November 10, 1910, when Wright Company pilot P.O. Parmalee (above) made the world's first commercial flight. In a Model B Flyer, Parmalee transported 10 bolts of silk, weighing 70 pounds, from Huffman Prairie in Dayton to Columbus, Ohio. The landing site was the Columbus Driving Park, located two and a half miles east of High Street in present-day East Columbus. The Morehouse-Mortens Company of Columbus paid $71.42 per pound to fly the silk to Columbus. The photograph below shows the flyer taking off at 10:41 a.m. It landed in Columbus at 11:47 a.m., having traveled a distance of 60.84 miles at an average speed of 55.31 miles per hour, the fastest speed to date for such a distance. The silk, valued at $600, was cut into small pieces and sold as souvenirs, generating a good profit. Unfortunately, the cost of shipping by air was so great it would be some time before another cargo flight was made. (Both courtesy of US Air Force Photo Archives.)

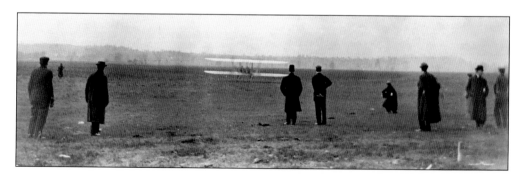

In 1916, Orville moved into a laboratory at 15 North Broadway Street. Called the Wright Aeronautical Laboratory, it was constructed for Orville's personal use on land the brothers had purchased in 1909. Among the many inventions created here was the split-wing flap, developed by Orville, which made diving possible during World War II. On January 27, 1948, Orville suffered a heart attack in the laboratory. He died in a Dayton hospital three days later. In 1971, the land was purchased by Sohio for a gas station and offered the building to any group interested in relocating it; none were able to raise the funds. In 1976, the building was demolished. Fortunately, the brick facade was saved. In 2003, Bank One donated the site to the Dayton Aviation Heritage Commission. In October 2004, the original brick facade was re-erected and a statue of Orville placed behind. (Above, courtesy of Special Collections and Archives, Wright State University; below, author's collection.)

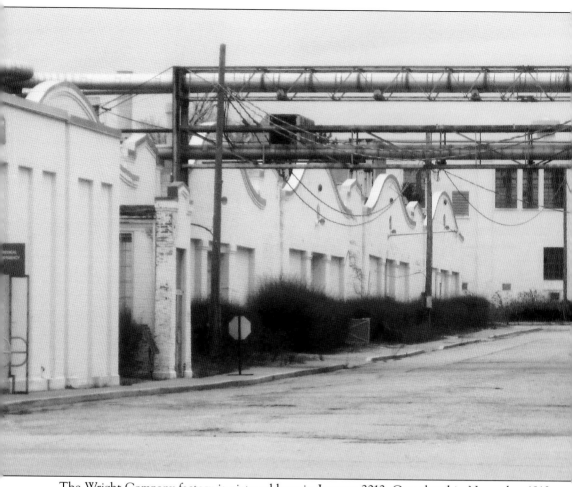

The Wright Company factory is pictured here in January 2012. Completed in November 1910, Building No. 1 (far left) is the world's oldest airplane factory. It is also believed to be the world's oldest surviving structure constructed for a purpose involving airplanes. The Wright Company left Dayton in the summer of 1917. From the fall 1917 until 1923, the buildings housed the Dayton-Wright Airplane Company's Plant No. 3, where metal fittings were made. General Motors (GM) acquired Dayton-Wright following World War I. Airplane production ended in 1923, but the Wright buildings continued to be used by GM's Inland Manufacturing Company to build automobile steering wheels. In 1989, Inland merged with the Delco Products Division, which became the Delphi Chassis Division. The original Wright Company buildings were now inside a huge industrial complex. Delphi closed on December 31, 2008. In 2011, the National Park Service acquired the rights to 70 acres surrounding the two original Wright Company buildings and three identical buildings added in the 1920s. Following demolition of the surrounding industrial complex, the original Wright Company factory will be turned into a museum, expected to open around 2015. (Author's collection.)

Three
THE DAYTON-WRIGHT AIRPLANE COMPANY

In 1917, the same year the Wright Company ceased aircraft production in Dayton, a new and larger aircraft company appeared. Initially known as the Dayton Airplane Company, it was the creation of four men: National Cash Register president Edward A. Deeds; Charles F. Kettering, inventor of the electric automobile starter; and the father-and-son team of H.E. Talbott Sr. and Jr. When Orville Wright joined as a consulting engineer, the company was renamed the Dayton-Wright Airplane Company. Edward Deeds realized the importance of aircraft production to the Dayton area. The closing of the Wright Company left many of the Wrights' skilled workers without jobs. Deeds also saw aircraft production leaving Dayton. Determined to stop the flow, he established the Dayton-Wright Airplane Company inside a former generator factory in the town of Moraine, Ohio. Through his political connections, Deeds was aware that the US Army was about to enter the Great War in Europe and would soon need thousands of new aircraft to support the war effort.

Shortly after forming the company, Deeds enlisted in the US Army with the rank of colonel and was put in charge of procurement for the Aircraft Production Board. Deeds quickly divested himself from his holdings in the company before assigning two major productions contracts to it. During World War I, the Dayton-Wright Company was the nation's largest military aircraft manufacturer, ultimately producing more than 3,500 airplanes, as well as an amazing number of aviation firsts. Among the Dayton-Wright Company's inventions are the first retractable landing gear to fly in the United States, the world's first guided missile, and the first practical four-passenger cabin airplane. From 1917 until it was dissolved in 1923, the Dayton-Wright Airplane Company kept Dayton, Ohio, at the center of American aircraft production.

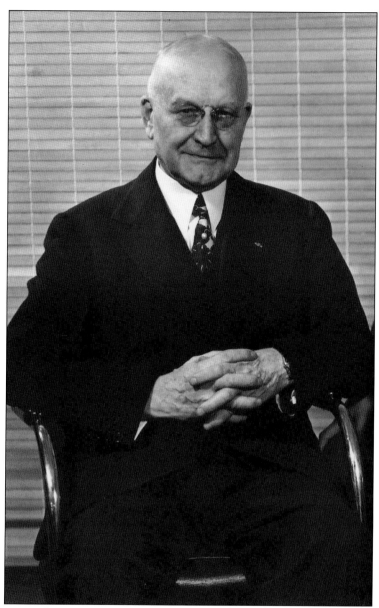

No one had more influence on aviation in Dayton than Edward A. Deeds (1874–1960). Deeds was president of National Cash Register (NCR) until he became too powerful for John H. Patterson and was forced out. Along with Charles F. Kettering, Deeds went on to cofound the Dayton Engineering Laboratories Company (known as Delco), the Dayton Metal Products Company, and the Domestic Engineering Company (later Delco-Light). He was also president of the Miami Conservancy District, which gave him influence over the use of thousands of acres of land along the Mad River, land he would later lease to the Army for the establishment of Wilbur Wright Field (WWF) and the Fairfield Aviation General Supply Depot. When he and Kettering founded the Dayton-Wright Airplane Company, its primary airfield was South Field, Deed's personal flying field in Morain, Ohio. The company's other airfield, near downtown Dayton, was leased to the Army by Deeds as the site for McCook Field. Though Wilbur and Orville invented the airplane in Dayton, it was Deeds who kept aviation in Dayton. (Courtesy of US Air Force Photo Archives.)

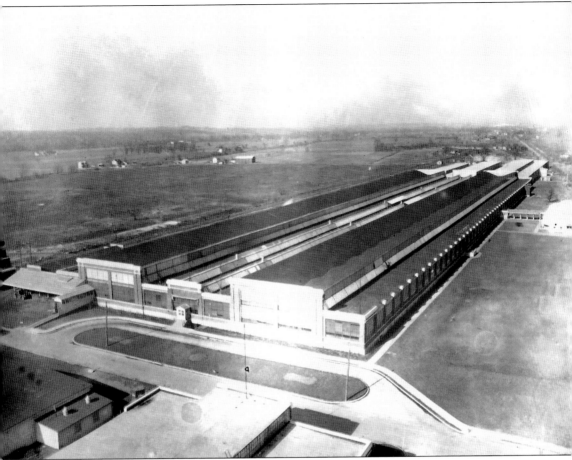

Plant No. 1 of the Dayton-Wright Airplane Company in Morain, Ohio, is pictured here as it appeared in June 1918. It had been built in early 1917 for Deed's (Delco-Light) to produce a low-cost electric generator for farms that had no access to electrical lines. Deed's partner, Charles F. Kettering, developed the generator. On August 1, 1917, Colonel Deeds was in charge of US Army aircraft procurement. He first awarded Dayton-Wright a contract to build 400 Standard J-1 trainers. On September 7, he expanded the contract to 400 J-1 trainers, 1,500 Martinsyde planes, and 2,000 de Havilland DH-9s. That contract was soon replaced with an order for 400 J-1s and 4,000 DH-4s. Deeds and Kettering arranged for Dayton-Wright to acquire the Domestic Engineering Company plant. Initially, the building measured 1,350 feet long and 270 feet wide, but it would soon need to be expanded. In 1917, five additional buildings were erected on Deed's South Field site in Morain (designated D1 through D5). (Courtesy of US Air Force Photo Archives.)

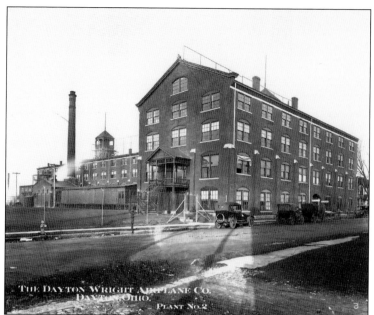

Plant No. 2, pictured here around 1918, was located in Miamisburg, Ohio, about five miles south of Morain and 11 miles south of Dayton. Inside the 100,000-square-foot building, the company produced propellers, landing gear, tailskids, struts, control cables, and wire. The factory lay on the Big Four railroad line, simplifying the transport of parts. (Courtesy of US Air Force Photo Archives.)

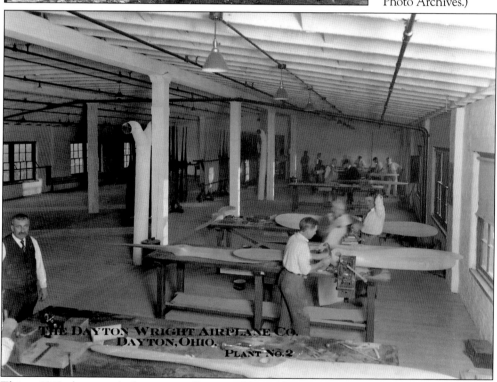

This c. 1918 photograph shows propeller assembly in Plant No. 2. Workers are using hand-held metal blades to rough out the propeller's shape. Afterwards, the propeller would be hand sanded to its finished shape. These two-bladed propellers are for early production DH-4s. Larger, four-bladed propellers would be used on the Liberty engine–powered DH-4 Liberty Fighter. The four-bladed Liberty propellers were purchased from Hartzell Propeller in nearby Piqua, Ohio. (Courtesy of US Air Force Photo Archives.)

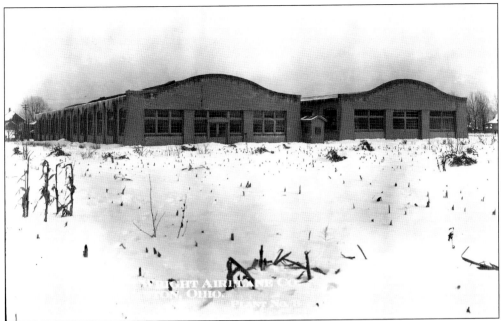

Plant No. 3 was the former Wright Company factory on West Third Street in Dayton. Dayton-Wright acquired the building in the fall of 1917, just a few months after the Wright Company moved out. Deeds hired virtually all of the Wright Company's former employees. Harvey Geyer, Jim Jacobs, and Charles Nellis were hired as supervisors of aircraft final assembly in Building D3 at South Field in Morain. Most former Wright employees were given supervisor positions because of their prior experience building airplanes. (Courtesy of US Air Force Photo Archives.)

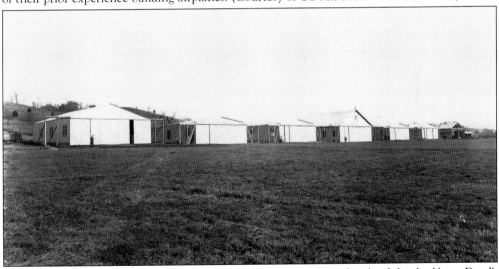

The Dayton-Wright Company's South Field test site was constructed on land that had been Deed's own personal flying field near Morain, Ohio. The field was about a mile away from the company's huge Plant No. 1. The buildings in this 1918 photograph are the company's experimental aircraft test hangars. Here, new designs were developed, assembled, and tested. Among the aircraft created in these hangars were the RB-1 Racer, the XPS-1 (the 1st Army plane with retractable landing gear), and the OW-1 Aerial Coupe (the last airplane designed by Orville Wright). (Courtesy of US Air Force Photo Archives.)

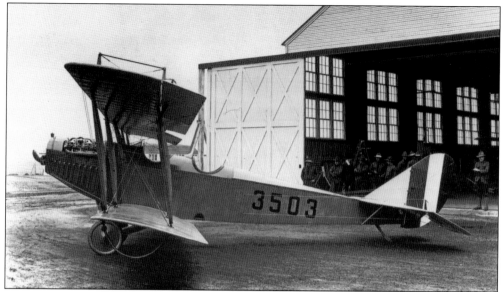

Dayton-Wright received a contract to build 400 Standard SJ-1s, the company's first airplane. Compared to the order for 4,000 DH-4s, this contract was practically a sideshow. The SJ-1 was very unpopular with instructors and students. Its unreliable four-cylinder Hall-Scott A-7a engine produced serious vibration. In June 1918, all Army SJ-1s were grounded. Most were later sold to the civilian market at bargain prices. (Courtesy of US Air Force Photo Archives.)

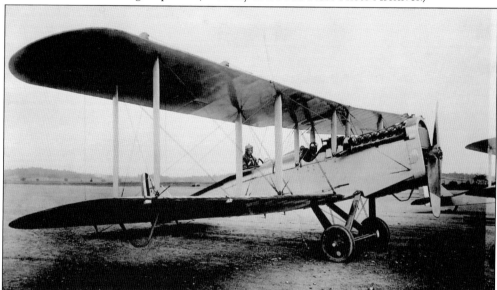

The DH-4 was Dayton-Wright's principle product. Here, one with a Cadillac engine is being prepared for a test flight on July 5, 1918, at South Field in Morain, Ohio. The DH-4 was a British aircraft, designed by Geoffrey de Havilland. Built as a light two-seat day bomber, it was considered the most successful single-engine bomber of World War I. When the United States entered World War I, the Army had no American aircraft able to compete with German fighters. Looking for an airplane that could be built in the United States, the Army selected the DH-4 to be its combat aircraft of World War I. Over 3,800 were built in the United States during the war; over 80 percent were constructed by Dayton-Wright. (Courtesy of US Air Force Photo Archives.)

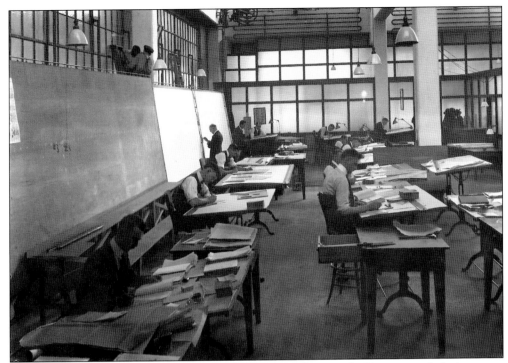

The drafting room in Plant No. 1 is seen in this 1918 photograph. Here, aircraft designs were turned into drawings and blueprints. Over a dozen draftsmen were employed, more than the entire staff of the former Wright Company. (Courtesy of US Air Force Photo Archives.)

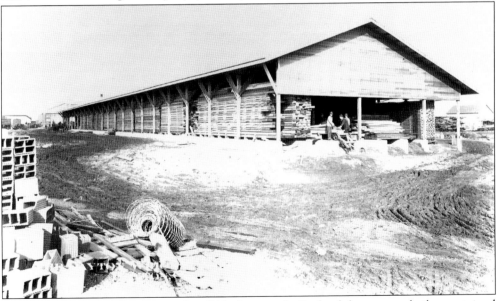

Wood Stockpile No. 1 is seen in this 1918 photograph. Each of the two stockpiles contained 500,000 board feet of aircraft-grade wood. The Dayton-Wright Company consumed so much wood, it built a dry kiln for processing, reducing cost and keeping the supply flowing. Such a huge quantity of wood was necessary for a company producing up to 40 airplanes a day. (Courtesy of US Air Force Photo Archives.)

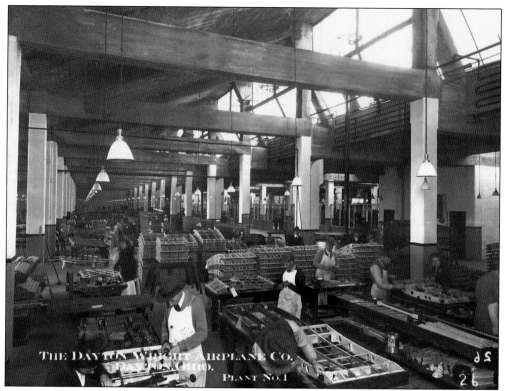

Wing assembly is seen in this 1918 photograph. The factory eventually grew to nearly 1,500 feet long—so large it disappears into the distance in this photograph. This was aircraft production on an industrial scale. Dayton's former Wright Company could produce only four aircraft a month. The Dayton-Wright Company had a contract to build 4,400 airplanes, more than the Wright Company could build in over 90 years. (Courtesy of US Air Force Photo Archives.)

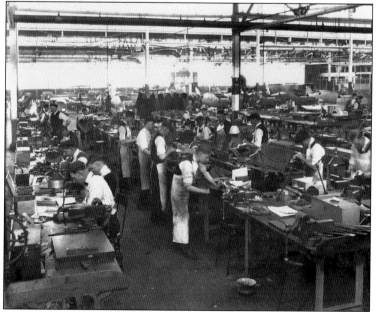

The component assembly area in Plant No. 1 is seen in this 1918 image. The Dayton-Wright Airplane Company employed a staff numbering over 8,000 at three sites and was one of the Dayton area's largest employers, rivaling even NCR. No one had ever seen aircraft production on such a scale before. Note the coatrack in the center of the work area. (Courtesy of US Air Force Photo Archives.)

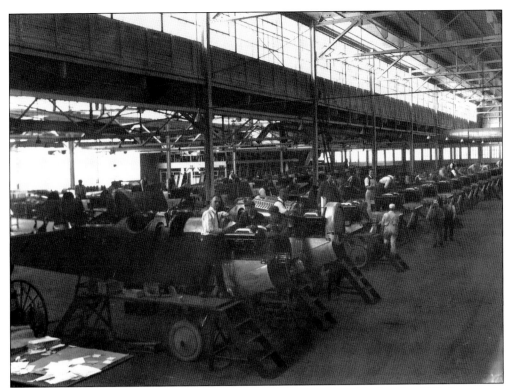

Workers are installing V-12 Liberty engines in DH-4 fuselages in Plant No. 1 in this 1918 photograph. Liberty-powered DH-4s were known as Liberty Fighters to separate them from British DH-4s with Rolls-Royce engines. Performance was similar with both versions. The British loved the DH-4, but American pilots were wary of them. The fuel tank, installed between the two cockpits, was particularly disliked. (Courtesy of US Air Force Photo Archives.)

Wing assembly in Plant No. 1 is seen in this 1918 image. Edward A. Deeds no doubt knew that his Army contract would be cancelled as soon as World War I ended. In an effort to complete all 4,400 aircraft before the secession of hostilities, production at Dayton-Wright escalated to a level never before seen in the United States. (Courtesy of US Air Force Photo Archives.)

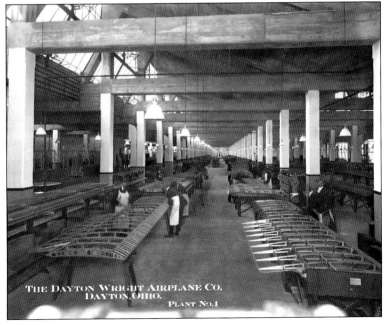

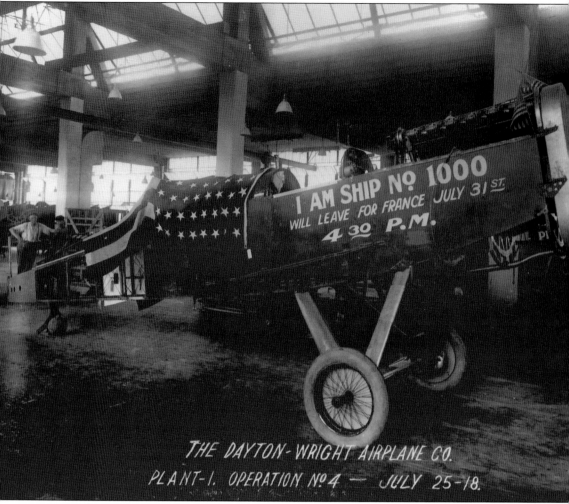

The thousandth DH-4 built by Dayton-Wright is seen in this July 1918 photograph just 10 months after the company built its first airplane. At the peak of production in the summer of 1918, Dayton-Wright was producing an astonishing 40 airplanes a day. One day's production was 10 times the number produced by the Wright Company in a whole month. Never before or since has an aircraft manufacturer produced aircraft at such a rate. Even at the height of World War II, "Rosie the Riveter" rarely produced more than one airplane an hour. Today, warplanes such as the F-22 Raptor are produced at a rate of one or two a month. As aircraft continue to grow in complexity, it is very unlikely any future aircraft manufacturer will ever again match Dayton-Wright's amazing record. (Courtesy of US Air Force Photo Archives.)

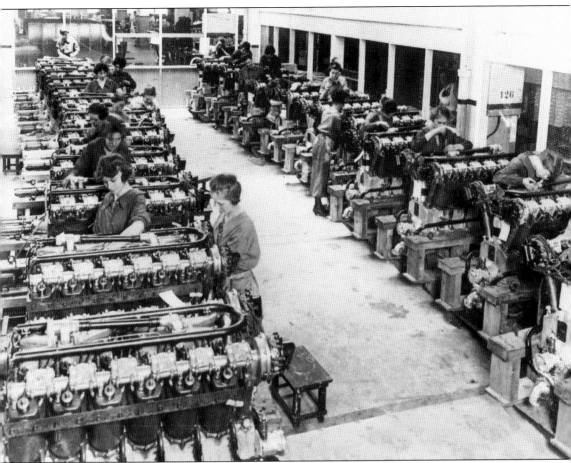

Female employees are working on Liberty engines in Plant No. 1's Motor Department in this July 1918 image. The Liberty engine was developed at Dayton's McCook Field at the insistence of Edwards A. Deeds, who believed that America needed an indigenous power plant equal to European engines. The Liberty was a 27-liter (1,649-cubic-inch) V-12 engine that produced 400 horsepower. The War Department awarded contracts to Buick, Ford, Cadillac, Lincoln, Marmon, and Packard. Over 12,500 Liberty engines were built by the time production ended in 1919. State of the art when introduced in 1917, the Liberty was soon surpassed by improved designs, but with 12,000 in inventory the US Army insisted the Liberty be incorporated into virtually every new aircraft introduced, handicapping planes like the Barling Bomber. Meanwhile, the Navy, which had largely ignored the Liberty, continued the evolution of radial engines, giving them a brief advantage. Still-crated Liberty engines often lay unopened in Army depots for years, though rumors of thousands of Libertys dumped into Lake Erie to form break walls are probably apocryphal. Liberty engines can be seen on display in Dayton at the National Museum of the United States Air Force and the Packard Museum. (Courtesy of US Air Force Photo Archives.)

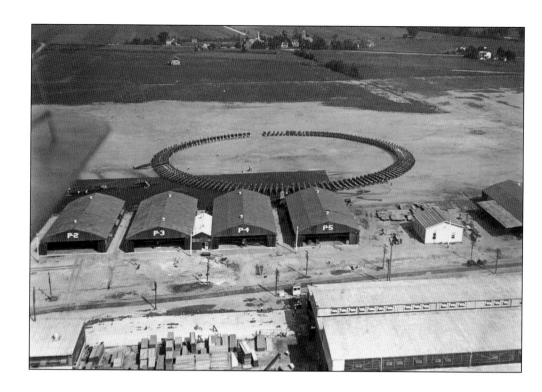

In the photograph above, 100 DH-4s with their wings folded form a circle at Dayton-Wright's South Field. The first 20 out of every 100 airplanes produced were test flown at South Field for quality control. Below, 151 DH-4s await shipment to Europe. With the signing of the armistice, the War Department ordered Dayton-Wright to cease production at 3,500. In the end, 3,106 DH-4 were produced by Dayton-Wright in all versions. Of them, 1,885 reached France by the war's end, with about 550 seeing combat. Most of the DH-4s that made it overseas were burned at war's end to avoid the cost of shipping them back in what became known as the billion-dollar bonfire. In the United States, DH-4s saw extensive service with the US Army Air Corps, which retired its last DH-4 in 1932. In 1924, the US Postal Service used DH-4s to establish transcontinental airmail service between San Francisco and New York and continued using them until the service was privatized in 1927. (Both courtesy of US Air Force Photo Archives.)

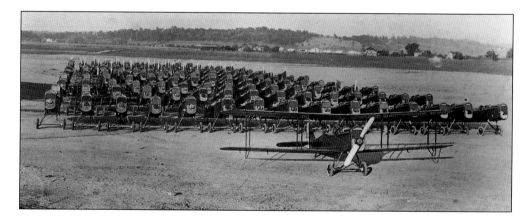

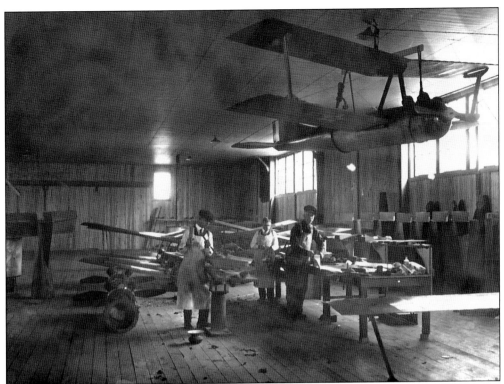

During World War I, the Dayton-Wright Company manufactured the world's first guided missile, the Kettering Aerial Torpedo, better known as the "Bug." A $400 papier-mâché biplane with 12-foot cardboard wings, the bug was the brainchild of Charles F. Kettering (1876–1958), inventor of the electric automobile starter. Powered by a small 40-horsepower De Palma engine, it could carry a 200-pound warhead 75 miles at a speed of 50 miles per hour. Its propeller was designed by Orville Wright in his North Broadway Street laboratory. First tested on October 2, 1918, the Bug was designed to fly a pre-set distance, at which point the engine would quit, the wings would fall off, and the torpedo would plummet to the ground. About 45 Bugs were produced. Though the Army had them in inventory before the armistice, none were sent overseas; officers feared they would land on friendly troops. A reproduction Kettering Bug is on display in Dayton at the National Museum of the United States Air Force. (Both courtesy of US Air Force Photo Archives.)

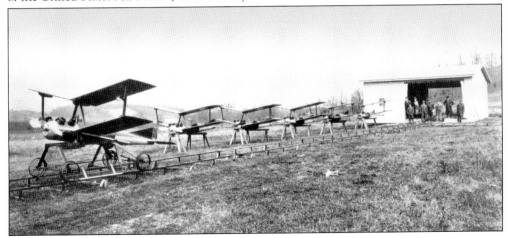

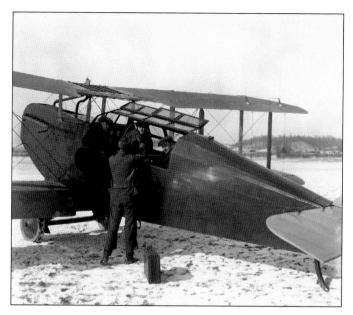

The end of World War I saw the termination of Dayton-Wright's DH-4 contract. To survive, the company looked for ways to modify DH-4s for the civilian market. Several DH-4s were modified to carry passengers in various arrangements. This image, taken on October 21, 1921, shows a Dayton-Wright KT Cabin Cruiser, a DH-4 with a glass canopy covering seats for a pilot and two passengers. Other versions were known as the DH-4B-5 and the Honeymoon Express. (Courtesy of US Air Force Photo Archives.)

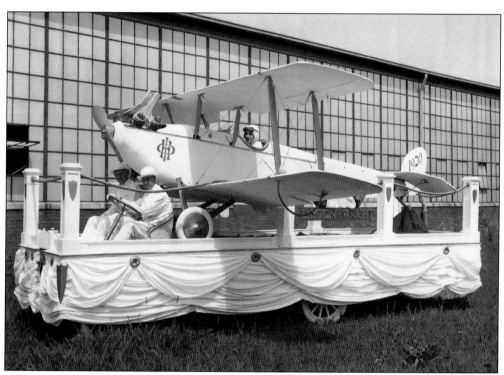

The tiny Dayton-Wright Messenger is seen as a parade float in 1920. Former Wright Company designer Harvey Geyer is driving. The passenger is Clarance Greke, while Helen Bradford sits in the cockpit. Only one Messenger was built. It used the same 50-horsepower De Palma engine as the Kettering Bug. Though offered for production, recent research suggests the Messenger was actually a piloted test bed for development of the Bug. (Courtesy of United States Air Force Photo Archives; donated by Theodore Litermoehlen.)

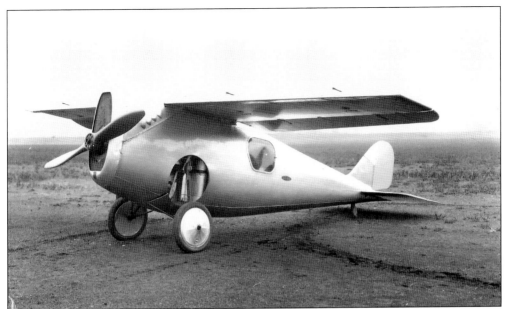

The Dayton-Wright RB-1 was a racer designed to enter the 1920 Gordon Bennett Race. It was the first aircraft with retractable landing gear to fly in the United States. The RB-1 featured a fully cantilevered, solid-core, variable-camber wing developed by Orville Wright. Powered by a 250-horsepower Hall-Scott L-6 engine, it was capable of speeds approaching 200 miles per hour. In France, the RB-1 was forced to drop out of the race due to a mechanical failure. Today, it is on display at the Henry Ford Museum in Dearborn, Michigan. In the photograph below, taken in 1920 at South Field in Morain, Ohio, from left to right are pilot Howard Reinhart, Jim Jacobs, F.P. Henry, Harvey Geyer, pilot Bernard L. Whelan, unidentified, Tom Midgley, J.H. Hunt, Mr. Bauman, Harold E. Tallet, Mr. Williams, and inventor Charles F. Kettering. (Courtesy of US Air Force Photo Archives.)

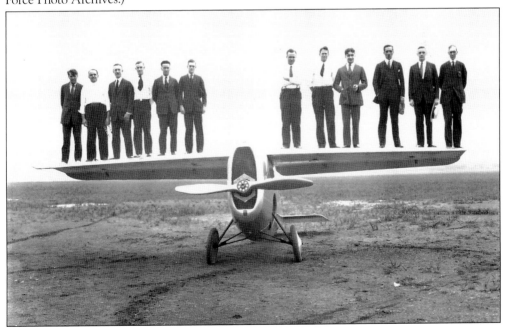

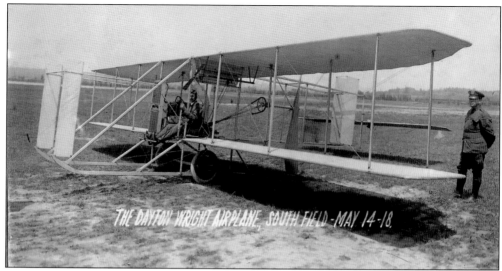

On May 14, 1918, Orville Wright took his last flight as a pilot. The crash in 1908 that killed Lieutenant Selfridge had badly injured Orville. Vibrations from airplane engines aggravated a back injury as well as several broken ribs that went unnoticed by doctors until the 1940s. On May 14, 1918, a lovingly restored Wright Model C Flyer was brought to Dayton-Wright's South Field. After carefully examining it, Orville decided to take it aloft. He circled the field several times before bringing it in for a picture-perfect landing. The Model C had a bad reputation as a pilot killer, but in Orville's hands it was as tame as a kitten. Orville never flew again, though on April 26, 1944, he briefly took the wheel of a Lockheed C-69 Constellation during a demonstration flight over Wright Field (below). He died in 1948 and is buried next to Wilbur at Woodland Cemetery in Dayton. (Both courtesy of US Air Force Photo Archives.)

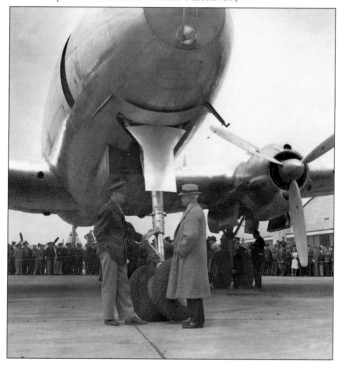

Four

THE DAYTON-WRIGHT
OW-1

The Dayton-Wright OW-1 Aerial Coupe was one of the most important aircraft ever designed and built in Dayton, Ohio. It was the last airplane designed by Orville Wright; the name OW-1 stands for Orville Wright-1. Working as a consultant at Dayton-Wright's South Field in Moraine, Ohio, Wright designed his Aerial Coupe in 1918. The single prototype was constructed in a hangar at South Field in 1919. The last Wright brothers' airplane was a unique four-passenger cabin plane developed from the DH-4, which the Dayton-Wright Company had been building by the thousands. It incorporated many new features, like a cabin door, that had never before been seen in a private aircraft. Orville's goal was to create a four-seat private plane with the interior of an automobile.

Unfortunately, the late 1910s were not a good time for aircraft manufacturers, as surplus World War I trainers could be bought for just a few dollars each. As usual, Orville Wright was ahead of his time. It would be several years before other manufactures would develop their own small cabin planes, but in Dayton, Ohio, in 1919, Orville Wright had created the world's first four-seat, single-engine cabin airplane, paving the way for the thousands of Cessnas, Beechcrafts, and Pipers that were to follow.

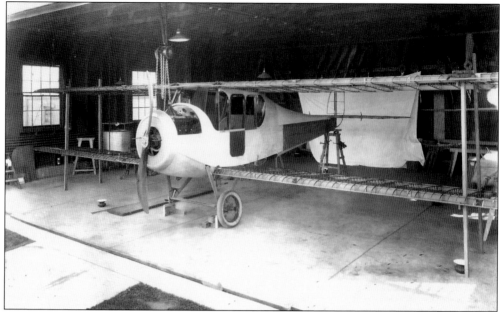

Above, the Dayton-Wright OW-1 is under construction in 1919 in a development hangar at South Field in Moraine, Ohio. The company's earlier efforts to produce a cabin aircraft resulted in the KT Cabin Cruiser, seen in the previous chapter. While the KT forced its passengers to sit inside the DH-4's cramped, narrow fuselage, Orville Wright took a completely different approach with his Aerial Coupe. He widened the fuselage to allow passengers to sit comfortably side by side in two rows. He also raised the cabin roof to give greater headroom. Initially, the OW-1 was built as a three-seater, with a single pilot in front and two passengers behind, but it was soon converted to two front seats. Dayton-Wright test pilot Bernard L. Whelan is in the pilot's seat in the image below. (Both courtesy of the US Air Force Photo Archives.)

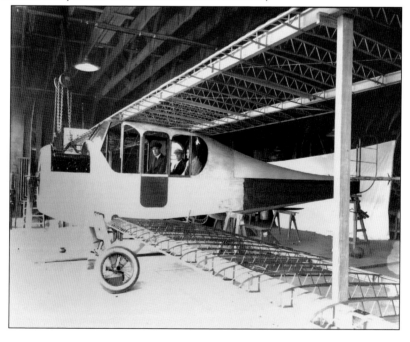

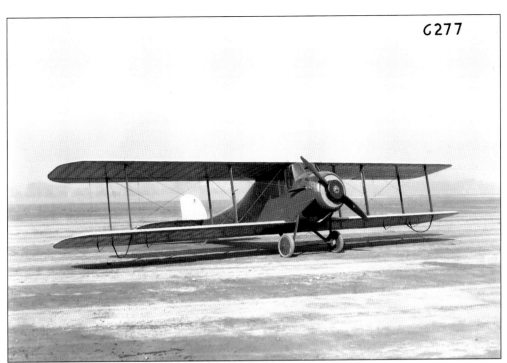

C277

Orville did away with the DH-4's traditional Liberty engine in favor of a smaller, lightweight, 150-horsepower Packard 8 (later replaced with a 180-horsepower Wright-Hisso). Though the plane appears to have a rotary engine, these were actually small in-line power plants. The wings and tail were heavily modified from a DH-4. (Courtesy of the US Air Force Photo Archives.)

The OW-1's door opened to the side like a car door. In every way possible, Orville designed the aircraft to give its passengers the impression they were riding in an automobile rather than an airplane. The OW-1 incorporated dual seats, located in two rows. It was the first private plane with such a seating arrangement. (Courtesy of the US Air Force Photo Archives.)

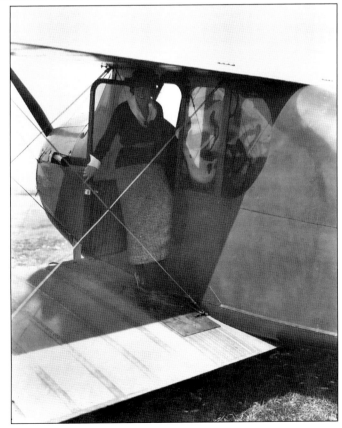

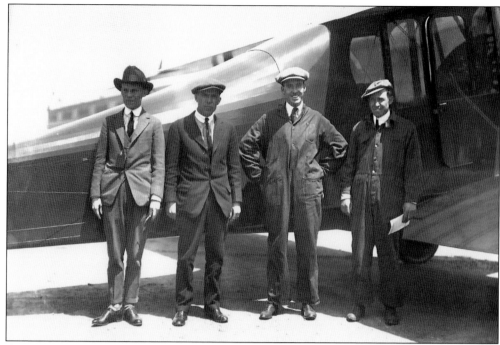

On May 22, 1921, the OW-1 set an altitude record of 19,710 feet (6,010 meters). At the time, it was the highest flight by a single-engine airplane with four passengers. The Aerial Coupe was flown by Dayton-Wright test pilot Bernard L. Whelan (above, second from the right), accompanied by three mechanics as passengers. It took the Aerial Coupe two hours and 31 minutes to reach the record altitude during the flight from McCook Field. With the closing of Dayton-Wright in 1923, the Aerial Coupe was sold to Whelan and former Dayton-Wright test pilot Howard Rinehart, who set up the Rinehart-Whelan Company in Moraine City, Ohio. They hoped to market the OW-1 and several other Dayton-Wright aircraft. Unfortunately, the following year Rinehart crashed the OW-1 in St. Louis during the 1924 On-to-Dayton Air Race. The wreck was sold to John G. Montijo, Amelia Earhart's flight instructor from Long Beach, California. Montijo cannibalized the OW-1 to build his own cabin plane, the *California Coupe*, and the OW-1 vanished from history. (Both courtesy of the US Air Force Photo Archives.)

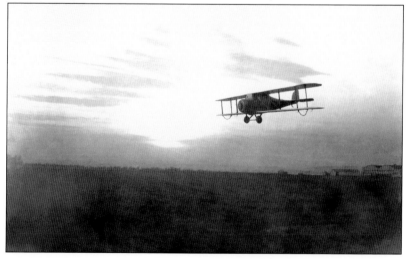

Five

McCook Field

Between 1917 and 1927, no military airfield in America was more important than McCook Field in Dayton, Ohio. By 1917, American aviators returning from Europe were telling of British, German, and French airplanes far more advanced than anything in the American arsenal. The United States had fallen behind, not just in aircraft design but in production as well. As the Wright brothers fought court battles to protect their patents, American aircraft development slowed. Meanwhile, the threat of war across the Atlantic had accelerated aircraft design there, as the great powers of Europe realized the value of the airplane as a war machine. By the time Orville Wright had secured his patents, the inventions the brothers had protected were already obsolete. To counter America's aircraft gap, the Aircraft Development Board created what has been called "the single most influential agency in the early years of American airpower—McCook Field."

In 1917, Edward Deeds was president of Delco, but he also had political connections in Washington, DC, and was a commissioned colonel in the US Army. Living in Dayton, Deeds was a strong supporter of aviation and was determined to keep the city the center of American aircraft development. In 1917, Deeds learned of the Army's troubled efforts to establish an experimental aircraft research facility in Langley, Virginia. Construction of the base was running late, and well over budget. America needed a research facility fast if it was going to be a participant in the air war in Europe. Deeds offered the Army a 254-acre airfield, located just north of downtown Dayton along the Great Miami River. Named for the Fighting McCooks, a Civil War family who once owned the land, McCook Field officially opened on December 4, 1917.

From 1917, until it relocated to Wright Field in 1927, McCook Field was the headquarters of the US Army's Airplane Engineering Department, whose purpose was to develop, test, and evaluate US aircraft, as well as those of allies and enemies. Every aircraft in the Army's inventory was tested and developed at McCook Field, as well as the engines that powered them, the instruments that guided them, and the vehicles that supported them. Between 1917 and 1927, McCook Field was the epicenter of aircraft research and development in the United States.

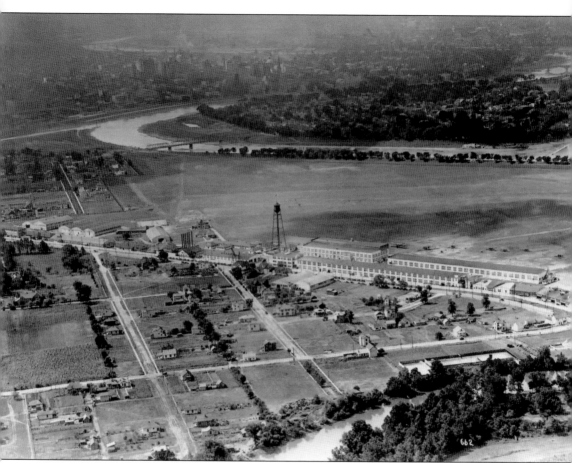

From 1917 until 1927, Dayton residents were able to witness aviation history unfold before their eyes without ever leaving their offices. This aerial photograph, taken around 1921, shows how close McCook Field was to downtown Dayton. Located at a bend in the Great Miami River about a mile and a half from downtown, aircraft flying from McCook Field were easily visible to workers in city office buildings. In the skies above downtown Dayton, aircraft from McCook Field regularly set new world records for altitude, tested the world's first pressurized cabins, and landed with the first landing lights. When they encountered trouble, McCook Field pilots used the world's first free-fall parachutes to escape to safety. From McCook Field, the world's first crop-dusting system was tested, night aerial photography was invented, and some of the greatest names in aviation learned their trade. In the 1920s, there was no airfield in America more important than McCook Field. (Courtesy of US Air Force Photo Archives.)

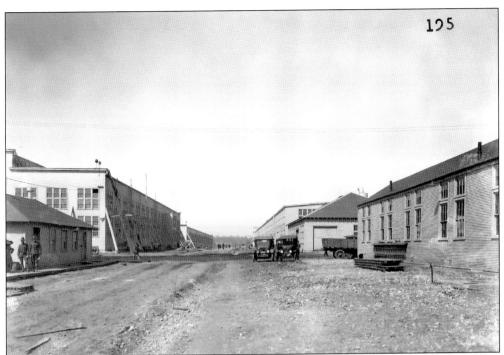

Prior to the Army's arrival in 1917, the site known as North Field was owned by the Dayton-Wright Aircraft Company. When a joint Army-Navy plan to construct a research station at Langley Field in Virginia encountered delays, Edward A. Deeds, co-owner of the Dayton-Wright Aircraft Company, first offered the Army the company's 120-acre South Field near Moraine, Ohio. Dayton-Wright employees objected because they needed that field to test their DH-4 Liberty Fighters, so Deeds quickly changed the offer to the larger North Field, which was accepted. McCook Field was named for Alexander McDowell McCook, a local Civil War general. Along with his brothers and cousins, they were known as The Fighting McCooks. McCook Field was only intended to be a temporary base; all the buildings at McCook were constructed of wood to make them easy to disassemble and move. (Both courtesy of US Air Force Photo Archives.)

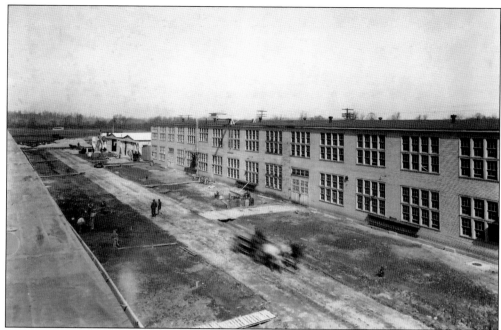

Construction contracts for the first buildings were awarded to the Dayton Lumber and Manufacturing Company on October 2, 1917, two days before the lease was even signed. Actual construction work began on October 10. According to Capt. H.H. Blee, the work "pushed ahead with astonishing rapidity. Large forces of workmen were employed working in shifts day and night, seven days a week." A total of 900 men worked in two shifts, 24 hours a day. The Wood and Metal Shop (above) was the first to be completed. Workers began installing machinery while the building was under construction. Work on the Final Assembly Building (below) began on October 25. Four hundred workers assembled it in 35 days, working in two shifts. By the fall of 1917, nine buildings had been completed, including the Engineering and Shops Building, the Final Assembly Building, Main Hangar, Garage, Barracks, Mess Hall, Cafeteria, Transformer House, and engine test stands. (Both courtesy of US Air Force Photo Archives.)

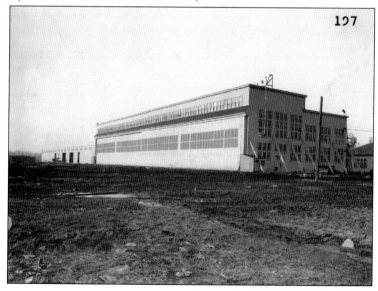

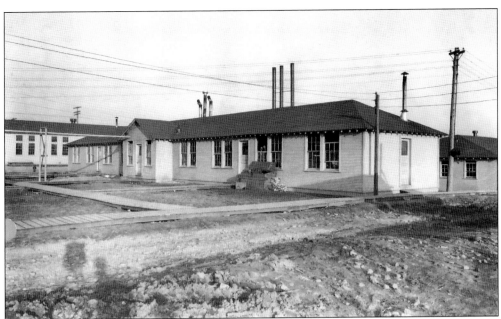

Like all the buildings at McCook Field, the mess hall was constructed of wood. Over 1,200 employees ate their meals here daily. By the first week of December 1917, enough buildings had been completed to allow members of the Airplane Engineering Division to move from their temporary location in downtown Dayton to the new field. McCook Field's official opening date was December 4, 1917. Even after the majority of base buildings had been occupied, there was not enough room at McCook to house all the base employees. Some staff continued to work at the Lindsey Building in downtown Dayton. There was never enough space at McCook for everyone, and the Army Air Service was soon forced to lease office space in the Dayton Savings Building at 25 North Main Street, the Mutual Home Building at 40 North Main Street, and the Air Service Building (later named the Knott Building). (Both courtesy of US Air Force Photo Archives.)

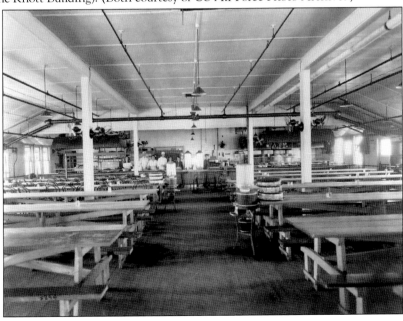

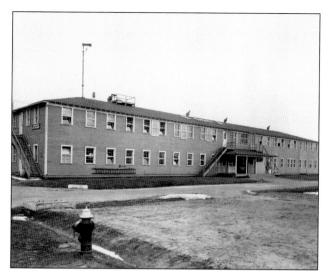

Perhaps the most important building at McCook Field was the Equipment Section Building. Inside this humble wooden structure, all equipment except the radio was developed, such as aerial photography, crop dusting, aerial mapping, high-altitude flight, electrical field equipment, wind cones, and clothing (including flying suits, helmets, moccasins, and gloves). Among the branches housed inside were the Instrument, Meteorological, Electrical, and Parachute Branches. (Courtesy of US Air Force Photo Archives.)

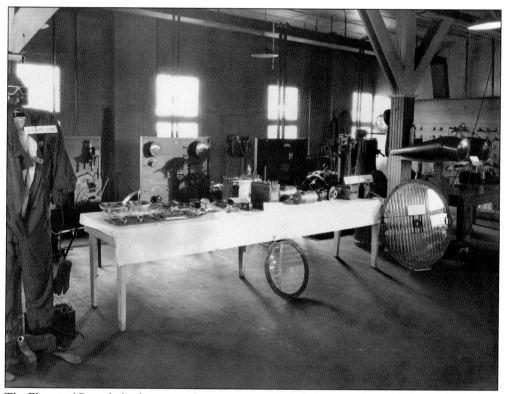

The Electrical Branch displays some if its inventions. Included among them are electrically heated flight clothing, aircraft generators, and landing and navigation lights. Electrically heated flight suits would play an important role in World War II. As bombers began flying higher and higher to escape attack by enemy fighters, gunners were exposed to lower and lower temperatures as they fired through the airplane's open sides. Exterior temperatures were often well below zero Fahrenheit, and electrically heated jackets and gloves helped make those missions possible. (Courtesy of US Air Force Photo Archives.)

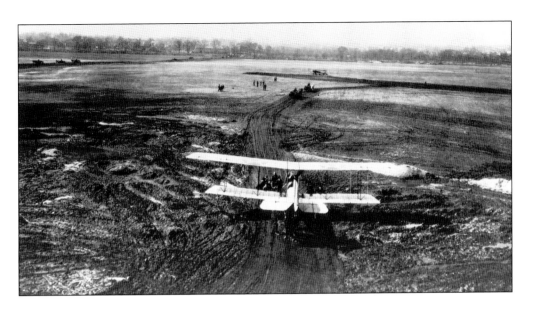

The field at McCook was intended for experimental flying. Months were spent grading the surface so that it was completely flat (above). A French drain and sink pumps were installed to handle drainage problems. The runway, laid out by Orville Wright, was 1,000 feet long and 100 feet wide, constructed of macadam and cinder. Prevailing winds forced the runway to be positioned along the shortest expanse of the field. Any aircraft that overshot or failed to get airborne would end up in the Great Miami River—and many did. While the length was sufficient for aircraft in 1917, it quickly became a disadvantage as larger and more powerful aircraft entered service. McCook's motto became "This Field Is Small—Use It All," which was painted above the main hangar in the mid-1920s (below). (Both courtesy of US Air Force Photo Archives.)

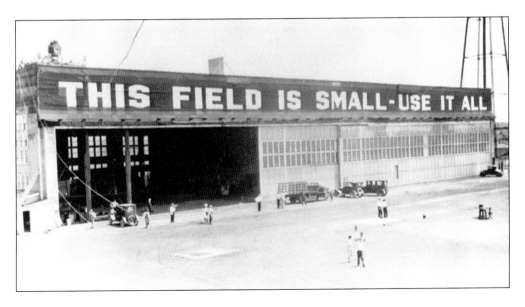

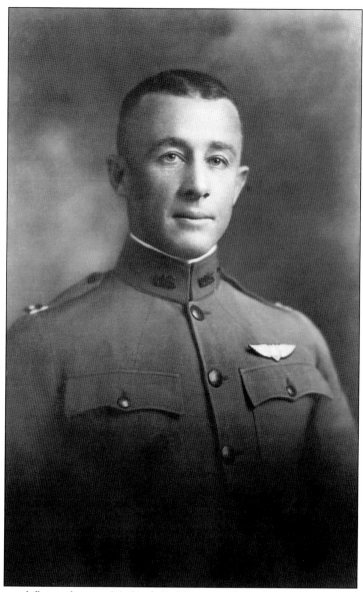

The experimental flying done at McCook Field attracted the best military pilots the United States could produce. Competition for the small number of test-pilot positions was often fierce. It was the place pilots went to prove that they had what author Tom Wolf called, "The right stuff." Among the few who could boast of having been selected are two pilots whose careers were so outstanding they could justifiably be called the "Chuck Yeagers" of their era. Nothing, it seems, was impossible for them. No height was too high, no distance too far for these men, who seemed to have collected virtually every aviation record the world offered. The first of these impressive flyers was Lt. John Arthur Macready (1887–1979). Lieutenant Macready remains the only pilot to earn three (consecutive) Mackay Trophies for breaking world records for altitude and duration, as well as a non-stop, coast-to-coast flight across the United States. Lieutenant Macready also made the first aerial photographic survey of the United States and flew the first experimental crop duster. Later, he served with the Twelfth Air Force in World War II, retiring from the military in 1946. (Courtesy of US Air Force Photo Archives.)

Lt. Harold R. Harris (1895–1988) was born on December 20, 1895, in Chicago, Illinois. In 1910, at age 15, Harris skipped school to attend the first National Aviation Meeting in Los Angeles. By 1920, he was head of the Flight Test Section at McCook Field. There, on June 8, 1921, Harris became the first pilot to fly a pressurized aircraft. On October 20, 1922, Harris made history as the first pilot to bail out of a stricken aircraft using a free-fall parachute. In 1923, he became the first pilot to fly the massive Barling Bomber, the world's largest aircraft. In 1924, Harris was one of the first pilots to fly the Emile Berliner Helicopter, the US Air Service's first experimental helicopter. He was also observed flying his DH-4 biplane under a bridge over the Great Miami River while upside down. By the conclusion of his test-pilot career, Lieutenant Harris held 16 American flight records and 10 world flight records. Harold R. Harris served in both world wars, retiring from the service in 1945 as acting chief of staff of Air Transport Command, having attained the rank of brigadier general. He went on to become vice president of Pan American Airlines. (Courtesy of US Air Force Photo Archives.)

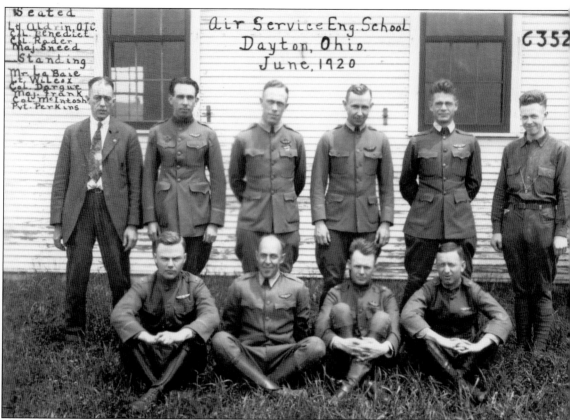

In 1919, the Army created the Air Service Engineering School. It was intended to teach officers the fundamentals of aeronautical engineering, including aircraft and engine design, maintenance, safety, armament, radio, and aerial photography. The first students were base commanders who would take what they had learned back to their bases and teach it to their staff. Lt. Edwin E. Aldrin Sr. (seated, far left), who had served on the staff of the Aeronautical Engineering School at Massachusetts Institute of Technology (MIT), was in charge of operations. The first class of 10 majors and lieutenant colonels began school on November 10, 1919, and graduated in September 1920. In 1946, the Air Force changed the name of the school to the Air Force Institute of Technology. In 1963, Lieutenant Aldrin's son Maj. Edwin Eugene "Buzz" Aldrin Jr., graduated from the same school, now located at Wright-Patterson Air Force Base. In 1969, Major Aldrin would become the second man to walk on the moon. (Courtesy of US Air Force Photo Archives.)

McCook Field was not just an air base, it was also an aircraft factory. World War I airplanes were made of little more than wood and fabric encompassing an engine. Once McCook engineers had the blueprints for an airplane, the base was equipped to replicate the entire aircraft, including the engine. The airplanes they built could be experimental models or copies of foreign aircraft needed for evaluation. Here, the Fuselage Assembly Section is seen in 1918. (Courtesy of US Air Force Photo Archives.)

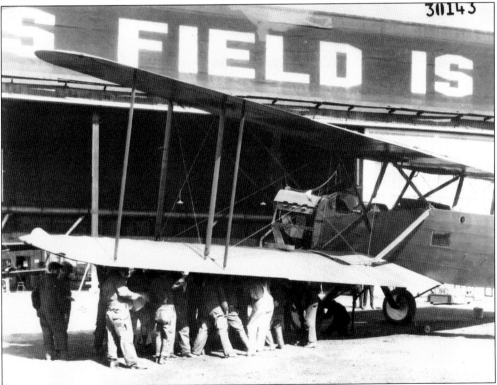

Aviation students from Antioch College and the University of Cincinnati are seen changing a tire on a Vought VE-7 Bluebird advanced trainer in this photograph taken on October 19, 1923. A dozen students and their instructor are literally lifting the biplane with their shoulders, while the ground crew changes the tire. Throughout its existence, McCook Field provided summer internships for aviation students from Ohio's colleges and universities, including Ohio State University and Ohio University in Athens. Many students stayed and became members of McCook's research staff. (Courtesy of US Air Force Photo Archives.)

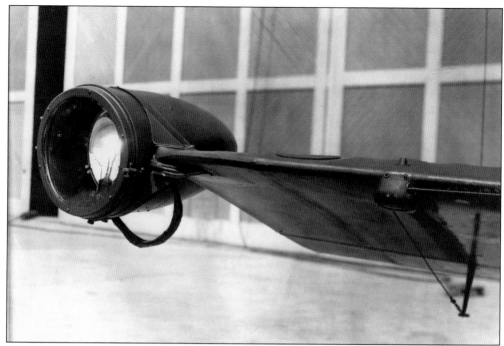

Two important inventions created by McCook Field engineers in Dayton were night landing lights (above) by the Equipment Section and airport support vehicles (below) by the Field Service Equipment Branch. The first night landing light was a 500-watt concentrated filament incandescent bulb that used a 12-volt current. It weighted 11 pounds and was tested on a DH-4. It made night landings possible at a time when almost no runways were lit. The airfield support truck was one of several support vehicles invented at McCook. It could transport gasoline, oil, and water to aircraft parked on the field. Today, such vehicles are a common sight at airports. (Both courtesy of US Air Force Photo Archives.)

Engines and metal components were manufactured in the base foundry. The McCook Field foundry could cast an entire engine from blueprints alone. In addition, it could produce the same engine in a variety of metals, including aluminum, brass, and bronze. The foundry furnaces, seen in this 1918 image, could also create steel and aluminum alloys for castings. Using these furnaces, McCook Field engineers developed the V-12 Liberty Engine in 1918. (Courtesy of US Air Force Photo Archives.)

Foundry workers pour molten metal into castings in this 1918 photograph. Ajax and Northrop furnaces are seen in the foreground with workbenches in the background. Here, pistons, camshafts, and whole engine blocks were cast in a variety of metals. (Courtesy of US Air Force Photo Archives.)

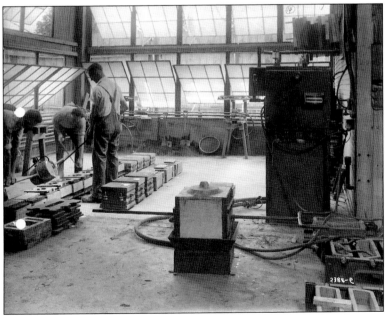

The propeller test rig is seen in these c. 1919 photographs. Wooden propellers failed frequently, sometimes with disastrous results (Orville Wright's 1908 crash). Wooden propellers were tested at McCook Field by attaching them to the front of an enclosed, bombproof structure (at left), and then a protective shroud was rolled into place to catch flying debris (below). The entire device was operated from inside the protective building. The propeller was spun at higher and higher revolutions per minute (rpm) until it failed. With this method, McCook engineers could determine the maximum rpm for a propeller design and learn which propeller manufacturers were producing the strongest, most reliable propellers. The propeller test rig was the last facility to close at McCook. This kind of testing became unnecessary with the introduction of metal propellers in the 1930s. (Both courtesy of US Air Force Photo Archives.)

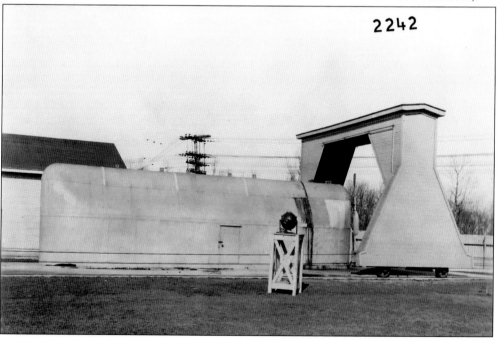

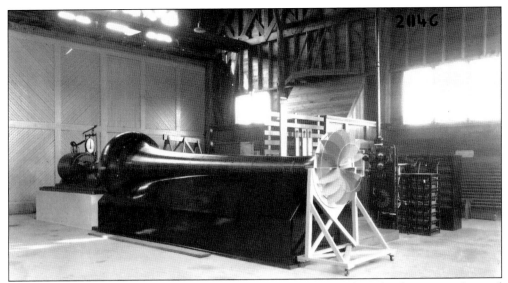

McCook Field's wind tunnel was one of the largest in the world. Nearly 20 feet long, it was designed and built at McCook in 1918. The 24-blade fan was 60 inches in diameter and produced a maximum air speed of 453 miles per hour at the 14-inch-diameter choke-point test area. It was used for calibrating airspeed instruments and testing airfoil designs. Today, it is on display at the National Museum of the United States Air Force in Dayton. (Courtesy of US Air Force Photo Archives.)

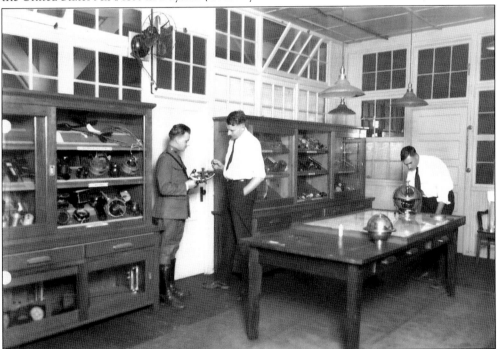

Lt. Alfred F. Hegenberger (left) and George P. Luckey (center) are seen in the Instrumentation and Navigation Branch Equipment Section. McCook Field had a collection of virtually every aircraft instrument ever developed. By testing them in the wind tunnel, engineers could determine which design was most accurate. McCook engineers also developed new navigation devices for the first non-stop cross-country flight on May 2–3, 1923. (Courtesy of US Air Force Photo Archives.)

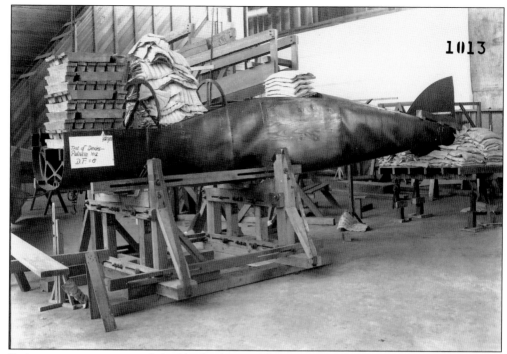

Fatigue testing was accomplished by loading sandbags on the fuselage and wings for extended periods. In this way, engineers determined the maximum stress the aircraft could withstand. In the photograph above, taken on July 29, 1918, a wooden fuselage is subjected to a fatigue test by covering it with sandbags. In the image below, taken in October 1918, the wings of a LUSAC-11 are undergoing fatigue testing. The number of sandbags was gradually increased until the wing spar failed. (Both courtesy of US Air Force Photo Archives.)

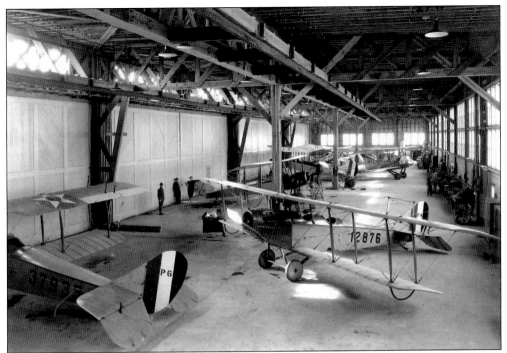

These 1924 photographs show the interiors of McCook Field's hangars. The image above shows a group of Curtiss JN-4 "Jenny" trainers and a lone Curtiss Model N, with landing gear in the rear. The aircraft in the image below are a mixed lot of fighter, trainer, and scout planes, including (front to back) the Vought VE-9 P-330 (s/n 22-399), Boeing DH-4M-1 P-332 (s/n 23-109), Fokker CO-4A P-284 (one of five Dutch Fokker CO-4As built for the US Army), and the Engineering Division XTP-1 P-263 (the only one built). (Both courtesy of US Air Force Photo Archives.)

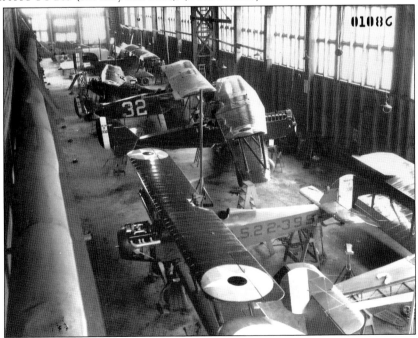

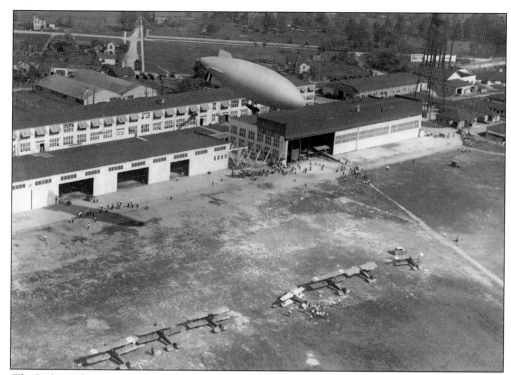

The Lighter-Than-Air Section's Goodyear Pony Blimp comes in for a landing in these photographs taken in 1920. The Army continued to explore lighter-than-air travel until abandoning the concept in 1937. In 1919, the Goodyear Company constructed three small Pony Blimps as powered observation platforms; one was based at McCook Field. The helium-filled envelope was only 95 feet long and 28 feet in diameter. Its three-passenger car was powered by a single 60-horsepower, Lawrence L-4, air-cooled engine. A lightening strike destroyed McCook's Pony Blimp on the ground at Wilbur Wright Field on September 30, 1921, injuring a watchman. Pony Blimps were the smallest airships used by the US military. (Both courtesy of US Air Force Photo Archives.)

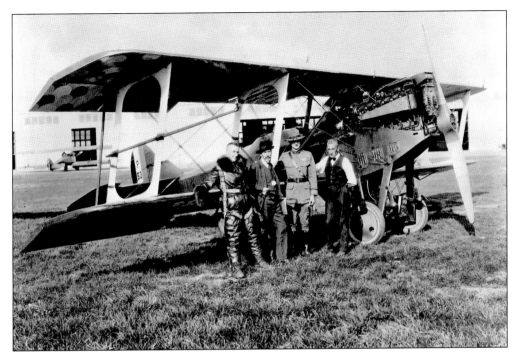

On September 28, 1921, Lt. John Arthur Macready set a new world altitude record of 34,509 feet while flying from McCook Field over downtown Dayton. Piloting a Packard-LePere LUSAC 11 biplane equipped with a supercharger designed at McCook Field (visible above the propeller hub), Macready set the record. He used supplemental oxygen and wore a special flying suit (at right) that protected him, head to toe, from temperatures that reached 70 degrees below zero Fahrenheit. For setting the record, he was awarded his first of three consecutive Mackay trophies. Later that year, he beat his record with an altitude of 40,800 feet. (Both courtesy of US Air Force Photo Archives.)

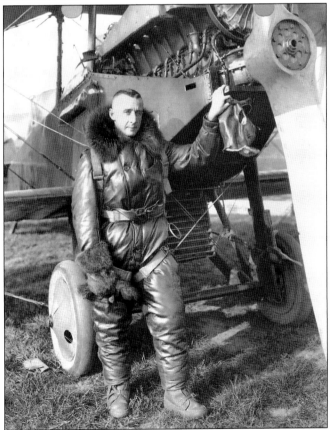

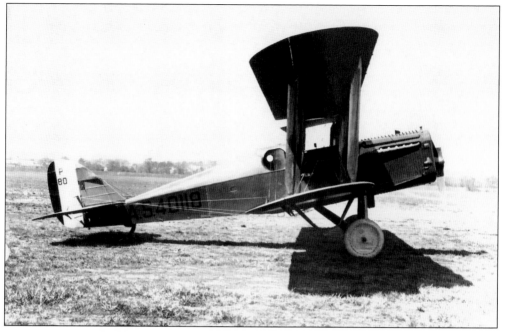

On June 8, 1921, Lt. Harold R. Harris became the first pilot to fly a pressurized aircraft when he successfully flew a Dayton-Wright USD-9A with an experimental pressurized cockpit. Two other test pilots had previously tried to fly the aircraft without success, including Lt. John A. Macready, who held the world altitude record in an oxygen-equipped unpressurized aircraft. The USD-9A had an airtight spherical chamber in place of a cockpit. The chamber had only a control stick and small portholes to view the instruments, which had been relocated outside. While at McCook Field, Harris held the prestigious title of chief of the Flight Test Branch, Engineering Division. (Both courtesy of US Air Force Photo Archives.)

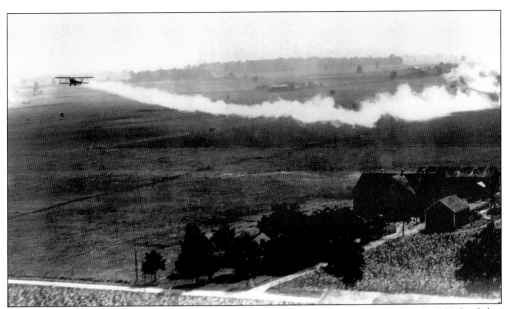

These two images show the actual moment a new industry was born. On August 3, 1921, Lt. John A. Macready, manning a modified Curtiss JN-4 "Jenny," made the world's first crop-dusting flight. The system was developed jointly by the US Department of Agriculture and the US Army Signal Corps under the direction of McCook Field engineer Etienne Dormoy. The "Jenny" was modified at to spread lead arsenate to kill catalpa sphinx caterpillars at a catalpa tree farm near Troy, Ohio. The test was considered highly successful, covering an area in a few minutes that would have taken hours to spray from the ground. In 1924, McCook Field test pilot Lt. Harold R. Harris cofounded the Huff-Daland Crop Dusting Company, the world's first commercial crop-dusting service. The company later evolved into Delta Airlines. (Both courtesy of US Air Force Photo Archives.)

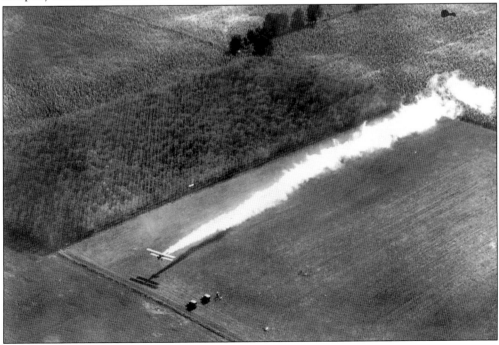

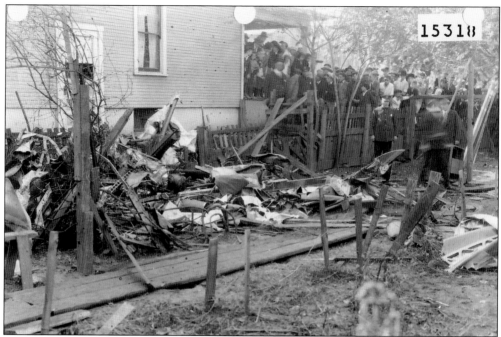

On October 20, 1922, Lt. Harold R. Harris again made history when he became the first pilot to bail out of a stricken aircraft using a free-fall parachute. Harris was flying over Dayton in a Loening monoplane with an experimental aileron when the aileron began oscillating badly, causing him to loose control. Fortunately, Harris was wearing a new parachute developed at McCook Field. Facing a certain crash, Harris bailed out of the stricken aircraft. The airplane crashed into the side yard of a double house that formerly stood at 403 Valley Street (now the site of a day-care center), seen above. Harris landed three blocks away in a grape arbor behind a house that still stands at 335 Troy Street, pictured below. He suffered only minor bruises, and there were no injuries on the ground. (Both courtesy of US Air Force Photo Archives.)

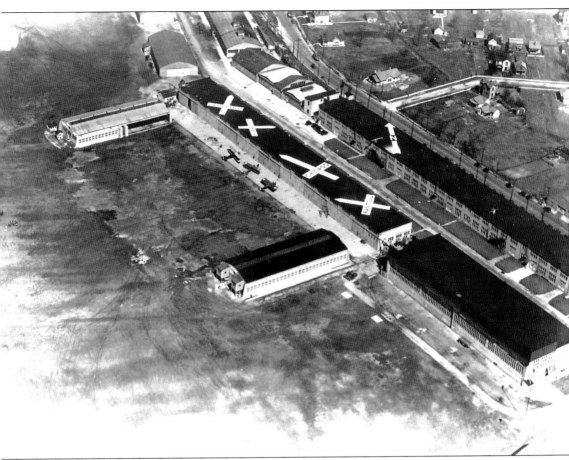

Seen here is the world's first successful night aerial photograph. Showing McCook Field's flight line and hangars, it was taken at 10:30 p.m. on July 14, 1926, from an altitude of 1,000 feet by pioneer aerial photographer George Goddard. Goddard studied aerial photography at Cornell University before organizing the Army's first aerial photographic units. He came to McCook Field in 1918 as director of the Photographic Branch, where he supervised research into new cameras and techniques, especially night photography. For this photograph, a biplane piloted by Lieutenant Brunner carried a five-foot wooden glider filled with flash powder. After lowering the glider, Goddard detonated the powder using his camera's shutter release, producing this exposure. Later, when another glider nearly collided with their tow-plane, Goddard invented flash bombs to illuminate the ground. Goddard's night photography methods were used extensively during World War II. (Courtesy of US Air Force Photo Archives.)

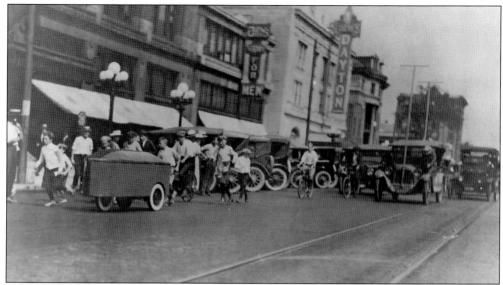

In 1922, a strange machine appeared on the streets of downtown Dayton. Called the Radio Dog, it was invented in 1920 at McCook Field's Radio Laboratory (below). The Radio Laboratory was exploring ways to control aircraft or vehicles by radio. The small cart was controlled by two engineers who followed behind in a Dodge Touring Car with a long antenna mounted in front (above). For fun, they frequently took the Radio Dog across the bridge to downtown Dayton, where it was turned loose on downtown streets to the amazement of onlookers. It is seen here traveling south on North Main Street in front of Rike's Department Store. The Radio Laboratory's radio-control research led to the development of World War II drone aircraft and Project Aphrodite: unmanned, radio-guided bombers filled with explosives. (Both courtesy of US Air Force Photo Archives.)

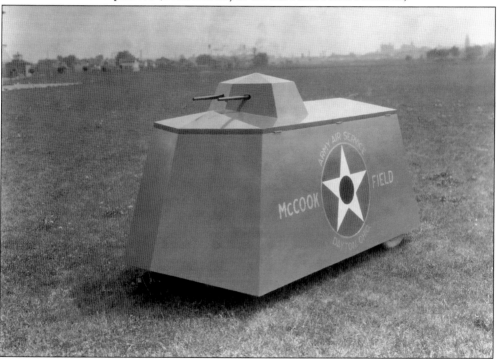

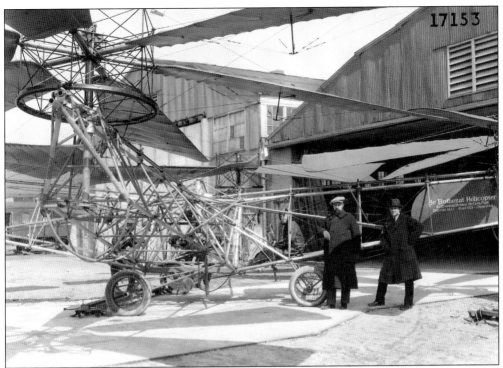

In March 1922, the Army assembled and tested its first helicopter at McCook Field. The machine, known as the *Octopus*, was designed and built at McCook by Russian-born rotorcraft pioneer George de Bothezat. It featured four six-bladed rotors at the end of long girders. Two vertical propellers provided side-to-side movement. Control came from two steering wheels, a control stick, and foot pedals. It first flew on December 18, 1922, piloted by Major T.H. Bane of the Engineering Division, rising to a height of six feet, seen below. The machine made over 100 flights, carrying up to four passengers, and once rose to a height of 30 feet. Thomas Edison called it "the first successful helicopter," but in 1924 the Army scrapped it. Pictured above on March 20, 1923, are, from left to right, Maj. Thurman H. Bane, George de Bothezat, and Mr. Eremeef. (Both courtesy of US Air Force Photo Archives.)

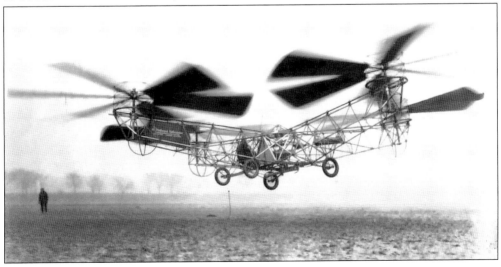

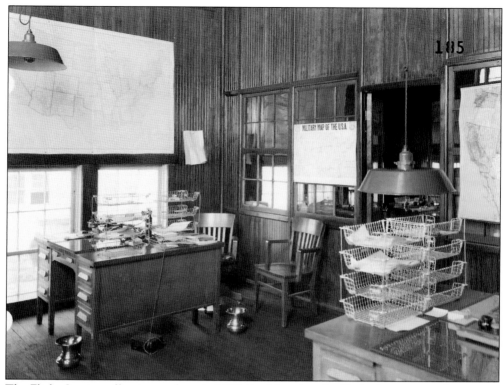

The Flight Section office is seen here in 1918. By this point, the Flight Section was doing most of its flying from Wilbur Wright Field, but pilots remained based at McCook. The majority of the best pilots in the US Army passed through this office to get their flight assignments. The world's first crop-dusting flight was scheduled here, as well as a string of world record–breaking altitude flights. Notice the two spittoons on the floor. (Courtesy of US Air Force Photo Archives.)

The office of the commanding officer of McCook Field is seen in this 1918 photograph. Intended as a temporary base, virtually all the buildings and furnishings at McCook were made of wood to make relocation easy. Note the early-style telephone and metal thermos on the desk. (Courtesy of US Air Force Photo Archives.)

On May 2, 1923, Lt. John A. Macready (left) and Lt. Oakley G. Kelly (right) made the first nonstop transcontinental flight. The staff at McCook Field modified the base's Fokker T-2 to carry 620 gallons of gasoline. After two aborted attempts in 1922, the pair tried for a third time in May 1923. Taking turns sleeping, they arrived in San Diego 26 hours and 50 minutes later, having traveled 2,521 miles nonstop. For the flight, Macready won his third consecutive Mackay Trophy. (Courtesy of US Air Force Photo Archives.)

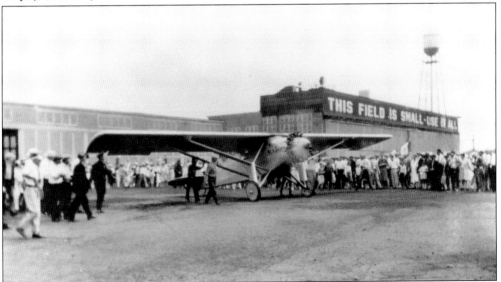

On August 5, 1927, Charles Lindbergh arrived at McCook Field as part of his national tour. Returning to the United States on June 11, 1927, Lindbergh embarked on a three-month cross-country tour on behalf of the Daniel Guggenheim Fund for the Promotion of Aeronautics. The 1927 Lindbergh tour visited 48 states and 92 cities, and he delivered 147 speeches and rode 1,290 miles (2,080 kilometers) in parades. (Courtesy of US Air Force Photo Archives.)

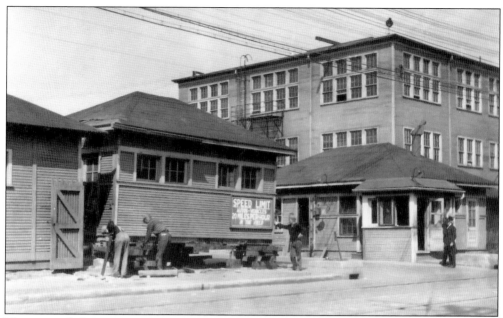

Never intended as a permanent site, McCook Field had rapidly outgrown its small location near downtown Dayton. The Army was actively looking for a new location, and it was searching outside Dayton. Local residents reacted by mounting a campaign to keep the base in Dayton. The head of the effort was National Cash Register's (NCR) owner, John H. Patterson. Patterson offered to give the Army a 4,988-acre site east of Dayton that included Wilbur Wright Field and the Huffman Prairie. In just two days, Dayton's citizens raised $425,673 to acquire the land, which was named Wright Field. Moving day to Wright Field was March 25, 1927. Most of McCook's buildings were made of wood and were simply loaded on trucks for the short drive to their new home. (Both courtesy of US Air Force Photo Archives.)

Six

WILBUR WRIGHT FIELD

The second of Dayton's three original air bases was Wilbur Wright Field (WWF). The field was the brainchild of Edward Deeds, president of NCR. Deeds knew the Army was planning to construct several new airfields to train the hundreds of new pilots America needed to fight in World War I. Deeds knew of a site large enough to accommodate four squadrons. The 2,500-acre site was part of the Mad River floodplain under control of the Miami Conservancy District, of which Deeds was president. The site also contained the world's first airport, the Huffman Flying Prairie, which Deeds used as a selling point. The Army agreed, leasing 2,245 acres for $20,000 a year.

Construction of Wilbur Wright Field began on May 25, 1917, and continued around the clock. The first military personnel arrived on July 8, 1917. The final cost for constructing Wilbur Wright Field was $2,851,694. By the end of July, there were more than 800 personnel at WWF. Within a year, the number had risen to over 3,000.

Throughout 1917 and 1918, Wilbur Wright Field trained hundreds of combat pilots, graduating 796 pilots in the last six months of 1917 alone. It was also home to the Aviation Mechanics' School, which held its first classes on December 17, 1917. Despite difficulties finding qualified students, the school managed to graduate 1,181 aviation mechanics by the time it closed on April 7, 1918. The third school was the Aviation Armorers' School, which opened on February 4, 1918. The first class graduated on June 6. All 95 officers graduated, and 485 of 560 enlisted men completed the course.

On March 1, 1918, McCook Field, located about 10 miles away, requested the use of Wilbur Wright's larger field for testing experimental aircraft. The first McCook aircraft arrived on March 19. By the time McCook Field closed in 1927, virtually all of McCook's test flights were being conducted from Wilbur Wright's larger field. The spectacular Barling Bomber was flown exclusively from Wilbur Wright, as McCook was too small to accommodate it.

The end of World War I saw an end to Wilbur Wright Field's training classes. By 1919, most of the field's hangars and buildings were being used to store aircraft and parts for the Fairfield Aviation General Supply Depot, which acquired full control over the field by the end of that year. Although Wilbur Wright Field technically ceased to exist, McCook test pilots continued calling it Wilbur Wright Field for years to come (creating confusion for Air Force historians). Only when the field became a part of Patterson Field in 1931 did the name Wilbur Wright Field finally fade from use.

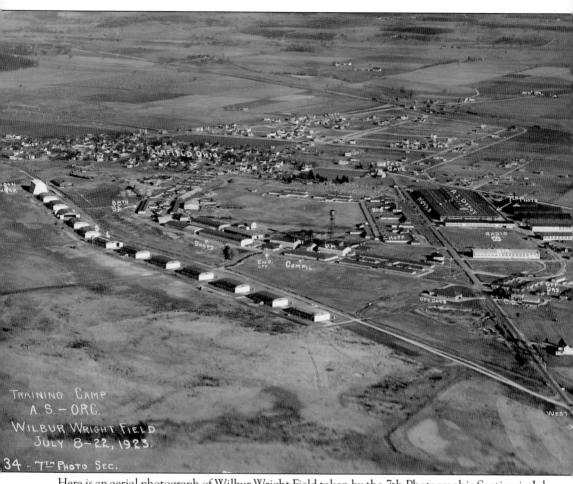

Here is an aerial photograph of Wilbur Wright Field taken by the 7th Photographic Section in July 1923. Many of the buildings are labeled in this photograph. Wilbur Wright Field had no runways; aircraft took off and landed from the open grass field. The base's 12 hangars each measured 120 feet by 66 feet. They were built on high ground away from the Mad River. A large, open drainage ditch crossed the flight line in a northeasterly direction. Flying operations were bordered on the south by the drainage ditch and on the north by the Mad River. The balloon hangar at the far end was a major post–World War I addition. The upper portion of the image shows the villages of Fairfield and Osborn, which merged in 1950 to become Fairborn. (Courtesy of US Air Force Photo Archives.)

Wilbur Wright Field's hangars are seen under construction in the c. July 1917 photograph above. The WWF occupied 2,500 acres along the Mad River floodplain. The first problem that had to be overcome was draining and grading the land. Elevation was between zero and two and a half feet above the river. Beginning on May 25, a workforce of 3,100 laborers worked 24 hours a day, seven days a week to have the field ready for the first group of flying cadets, who were scheduled to arrive from ground school at Ohio State University on July 17. The WWF was intended as a two-unit, four-squadron flying field: Unit One was the Signal Corps Aviation School, and Unit Two was the Aviation Mechanics' School and Aviation Armorers' School. Despite every effort, flooding, seen below, was a constant problem. The situation was particularly bad around the Unit Two hangars (known as the South Unit), which were located at a low spot between the flying field and the drainage ditch. (Both courtesy of US Air Force Photo Archives.)

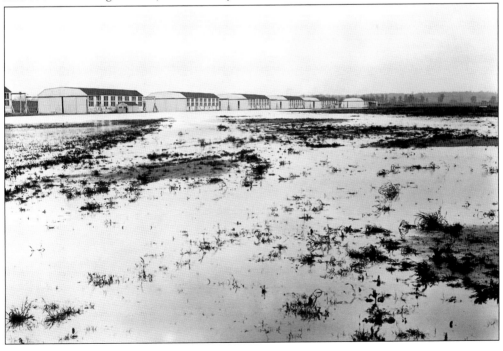

The tall man in front of the propeller hub in this May 1918 photograph is Lt. Frank Stuart Patterson, son of National Cash Register owner John Henry Patterson. On June 19, 1918, Patterson and his observer, Lt. LeRoy Amos Swan, went aloft in a DH-4 (s/n 32098) to test a Nelson machine gun synchronizer. Diving from 15,000 feet, the DH-4's wings suddenly collapsed. The aircraft plummeted to the ground, killing Patterson and Swan. Frank Stuart was buried next to his father at Woodland Cemetery. On July 1, 1931, Patterson Field in Dayton was named for Lieutenant Patterson. (Courtesy of US Air Force Photo Archives.)

Students of the Aviation Armorers' School are seen learning to adjust the timing on aircraft machine guns in this photograph taken in 1918. The school had two functions: one, to test all machine guns issued to the aviation section, and two, training new armament officers and their enlisted assistants. The six-week course trained armorers in the operation of machine guns, their sights and synchronization mechanisms, and the storage and mounting of bombs. (Courtesy of US Air Force Photo Archives.)

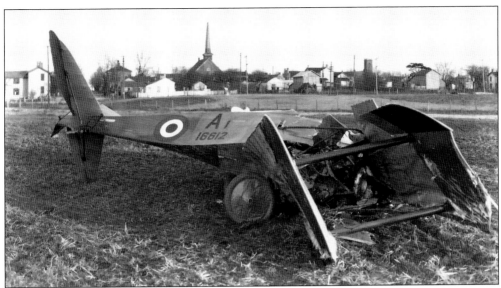

In February 1919, the Italian Air Force sent three of its best aircraft—a bomber, a scout, and a fighter—to WWF for the US Army Signal Corps to evaluate. The planes were accompanied by three of Italy's best pilots. On February 4, tragedy struck when Lt. Giovanini Pirelli's Ansaldo SVA fighter plummeted to the ground, killing him instantly. Lieutenant Pirelli was the first foreign pilot killed on US soil. Lieutenant Pirelli was buried on the airfield with full military honors. The photograph below shows officers at Pirelli's gravesite shortly after the ceremony. From left to right are Lt. Col. F.M. Andrews, Maj. Paolo S. Bernadori (Italy), Maj. Gen. Benjamin D. Foulois, Commander Silvioscoroni (Italy), and Maj. Henry "Hap" Arnold. Both Ben Foulois and Hap Arnold learned to fly at the Wright Flying School just a few thousand feet away at Huffman Prairie. Lieutenant Pirelli's grave can still be seen today along the flight line at Wright-Patterson Air Force Base. (Both courtesy of US Air Force Photo Archives.)

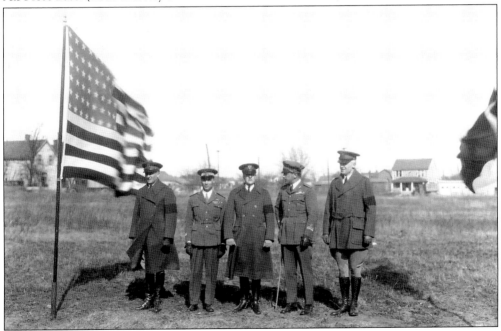

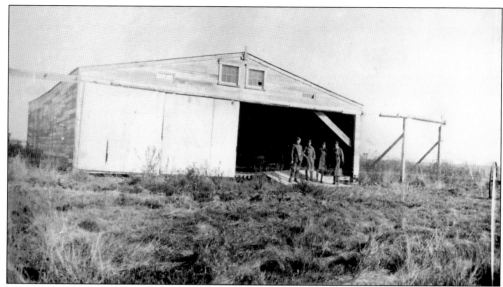

In May 1917, the Wright brothers' Huffman Prairie became a part of Wilbur Wright Field. The photograph above was taken by visiting Royal Air Force (RAF) Capt. A.R. Boeree. It shows the Wright brothers' hangar as it appeared in 1918. A group of RAF pilots is posing next to the historic building. The hangar was built in 1906 and was the second constructed by the Wright brothers on Huffman Prairie. Unfortunately, it was located in an area away from the airfield and was left to the elements. The photograph below was taken on October 17, 1939, just days before the historic hangar was demolished. A historical marker now stands on the site of the former hangar. (Both courtesy of US Air Force Photo Archives.)

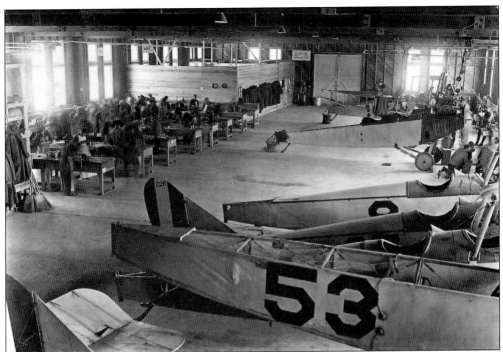

Instructors and students from the Aviation Mechanics' School study Curtiss JN-4A "Jenny" trainers in these c. 1918 images. Experience in World War I had shown that under wartime conditions, each airplane required a support staff of 47 ground personnel to keep it airworthy. Since pilot training moved south during the winter, the school opened on December 17, 1917, in the 12 Unit One hangars used for flying instruction. Instructors came from Selfridge Field in Mount Clemens, Michigan. Students were supposed to arrive having some experience in automotive mechanics, but many were found to have no experience at all. Worse yet, many students were illiterate or had limited ability to speak English. Despite this, the Aviation Mechanics' School graduated 1,181 aviation mechanics by the time it closed on April 7, 1918. (Both courtesy of US Air Force Photo Archives.)

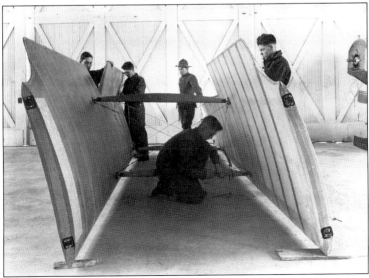

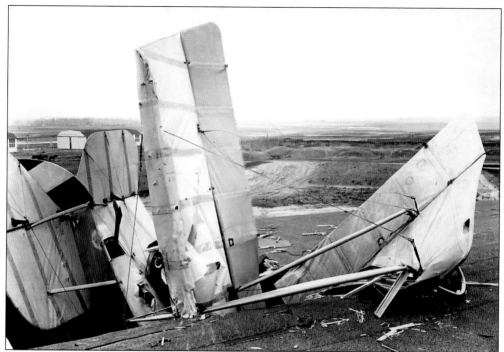

The Aviation School opened on June 28, 1917. An average of 160 students per month were enrolled in flight training. The two aircraft employed were the Curtiss JN-4D "Jenny" and the Standard SJ-1. The "Jenny" was much easier to fly; about 90 percent of all World War I pilots earned their wings in a "Jenny." Only 17 aircraft were lost in accidents, including this JN-4D, which plunged through the roof of a barracks on May 1, 1918. The cadet killed was on his first solo flight. (Both courtesy of US Air Force Photo Archives.)

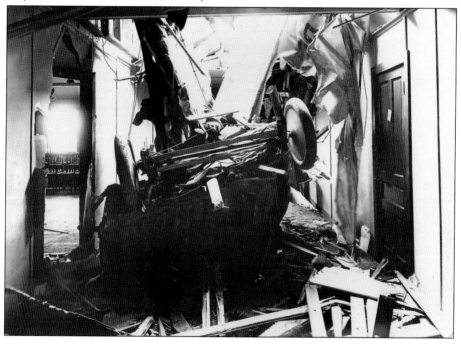

Seven

THE FAIRFIELD AVIATION GENERAL SUPPLY DEPOT

The Fairfield Aviation General Supply Depot (FAGSD) was located adjacent to Wilbur Wright Field on a 40-acre triangle of land purchased for $8,000 from the Miami Conservancy District. Ground was broken in September 1917, and the depot opened on January 4, 1918. Its intended mission was to receive, store, and distribute equipment for World War I air-training fields. The end of World War I saw the depot's mission change dramatically. Almost overnight, it became a clearinghouse for the disposal of surplus aircraft, engines, and parts left in the Army's inventory as the service demobilized. By 1919, the depot had gained control over Wilbur Wright Field, and its 77 buildings were filled with 700 aircraft, 2,500 aircraft engines, thousands of instruments, lumber, clothing, and equipment. It took the FAGSD eight years to liquidate it all.

On January 14, 1921, the facility became the Fairfield Air Intermediate Depot (FAID), providing supply, maintenance, repair, and overhaul to aircraft based at Army Air Service Bases, National Guard installations, and Reserve Corps sites. In 1934, the workforce at the depot was augmented by temporary laborers working under the Works Progress Administration (WPA). In 1935, a transient camp of 527 men lived at the depot. In exchange for 20 hours of work per week, they received lodging, meals, and a subsistence pay of approximately $1.50 per week in cash.

World War II saw significant increases in activity and another name change at Fairfield. Now called the Fairfield Air Depot, it became a central storage, repair, and overhaul center for Army Air Corps aircraft returning from overseas. Dozens of new buildings were constructed at the depot, including a hotel for traveling pilots. As the war wound down, the depot became a separation center for discharging veterans, processing more than 35,000 men by the conflict's end. Postwar reorganization called for the closing of the depot, and on January 1, 1946, the Fairfield Air Depot officially became part of Patterson Field.

Though the smallest of Dayton's three original bases, the Fairfield Depot outlasted McCook and Wilbur Wright Field by two decades and was the only one to serve through two world wars.

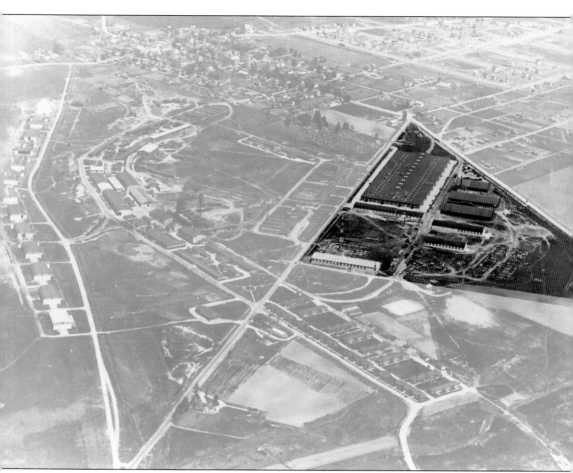

The borders of the Fairfield Aviation General Supply Depot are clearly seen in this c. 1923 aerial photograph. The FAGSD occupied a triangle of 40 acres of former wheat fields purchased from the Miami Conservancy District for $8,000. This image shows how small the FAGSD was compared to Wilbur Wright Field's 2,245 acres. There were no fences between the two bases. Though they operated as independent bases and reported to separate divisions, WWF and the FAGSD shared many of the same facilities. The depot opened with 150 troops on January 4, 1918. Later, in 1918, it hired seven civilian employees: six female clerk-stenographers and a male janitor. (Courtesy of US Air Force Photo Archives.)

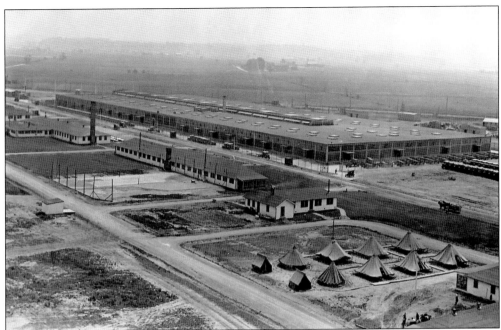

Central to the depot's mission was the construction of its main building, pictured above around 1919. It was a U-shaped, 234,000-square-foot structure. The depot featured a 600-foot, double railroad line running through its center, seen below around 1940. Completed in December 1917, the building cost $981,000. It housed the depot's headquarters, a Signal Corps weather office, and thousands of square feet of storage. Six other buildings, including three steel storage hangars and the depot's garage, were constructed nearby. The main building is now Building No. 1 of Wright-Patterson Air Force Base. It is the oldest permanent structure on the base. The center railroad line still exists, though railroad operations at Wright-Patterson ceased in 1993. (Both courtesy of US Air Force Photo Archives.)

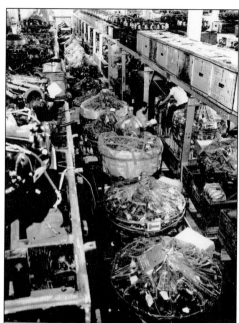

During both world wars, the Fairfield Aviation General Supply Depot shipped thousands of aircraft engines to all theaters of action. In this image, World War II aircraft engines are being covered with 235 layers of plastic film for protection before being shipped overseas. (Courtesy of US Air Force Photo Archives.)

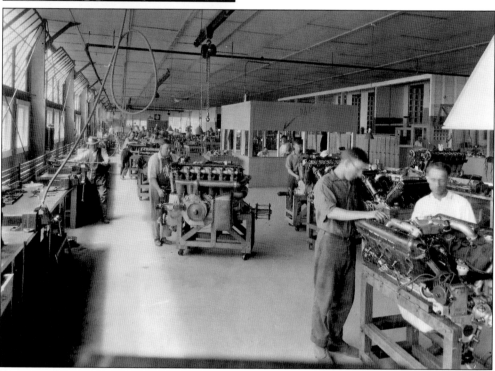

Depot interns are overhauling aircraft engines in January 1926. During both world wars, the depot was responsible for repairing and overhauling aircraft engines, many from aircraft returning from overseas. During World War II, the depot overhauled thousands of Allison engines used in the P-38 Lightening and P-40 Warhawk. In many instances, engines salvaged from destroyed aircraft were repaired and reused in other airplanes, shortening replacement time and reducing the Army's dependence on costly new replacements. (Courtesy of US Air Force Photo Archives.)

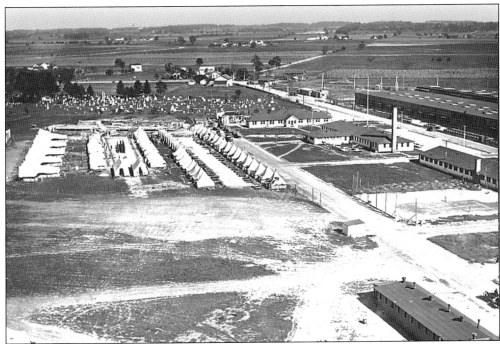

These 1918 photographs show the depot's World War I Tent City, occupied by troops of the 248th Aero Squadron. The triangular tents on the left in the image above contain the squadron's aircraft. Enlisted men's tents form two roads in the center. The permanent buildings on the right contain the base post exchange and bachelor officer's quarters. Building No. 1 is just visible on the right edge. The photograph below shows the cramped conditions soldiers endured. Each tent housed eight enlisted men. Flower gardens in front of the tents were planted and cared for by privates. (Both courtesy of US Air Force Photo Archives.)

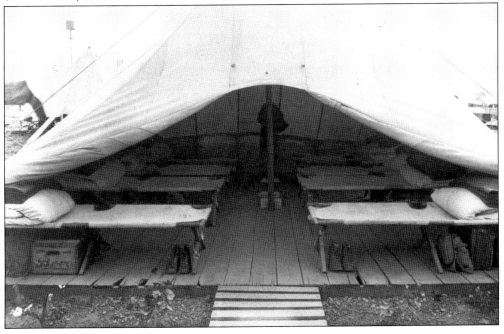

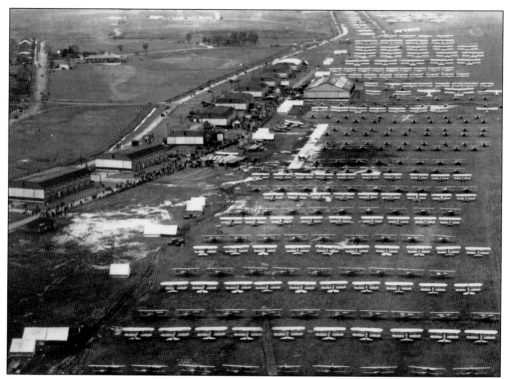

Perhaps the greatest gathering of American military aircraft during the 1930s was the 1931 maneuvers held at the Fairfield Air Depot Reservation (formerly Wilbur Wright Field). Forming an amazing collection of postwar aircraft, 672 aircraft of the First Provisional Air Division were in attendance for the 1931 maneuvers. The gathering included hundreds of small pursuit and reconnaissance aircraft (above), as well as dozens of large transports and bombers (below). Most of the transports in the image below are Ford Trimotors. The large aircraft at the bottom (NC336N) is the Army's sole YC-20, a military version of the Fokker F-32, the first four-engine aircraft developed in the United States. The odd twin-boom airplane marked NC23V (first row, far left) is a rare Sikorsky S-38B Flying Boat (s/n 414-14). (Both courtesy of US Air Force Photo Archives.)

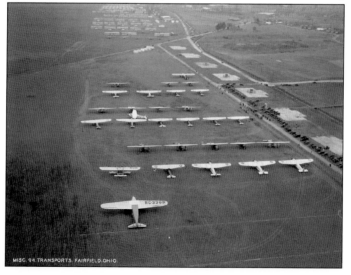

Eight

THE WACO
AIRCRAFT COMPANY

In 1923, the same year the Dayton-Wright Airplane Company closed, a new aircraft manufacturer arrived in nearby Troy, Ohio. The Weaver Aircraft Company (later changed to WACO) was founded in 1919 in Lorain, Ohio, by three former employees of the Curtiss Aeroplane Company's Cleveland factory. Clayton J. Brukner and Elwood "Sam" Junkins had been engineers for Curtiss, while George E. "Buck" Weaver had been a company test pilot. All three had worked on the Curtiss JN-4 "Jenny" trainer, which was built in Cleveland. The first WACO aircraft built in Troy was the Model 6, an inexpensive, two-seat biplane made from a modified Curtiss JN-4 "Jenny" trainer. When Curtiss sold the Cleveland plant, the three found themselves out of work. Brukner and Junkins had been working on modifications to the "Jenny" to make it more aerobatic and hoped to market their new design. Weaver provided the flying skills to test and promote the new airplane.

WACO moved briefly to Medina, Ohio, but a chance encounter in 1923 with a wealthy young man with an interest in airplanes brought the group to Troy, Ohio. Renamed the Advanced Aircraft Company, production was spread out over several rented buildings. At first, the company faced the same problem that had forced Dayton-Wright out of the civilian aircraft business: too many World War I surplus airplanes that could be bought cheap. By the end of the 1920s, that supply had dried up, and pilots were looking for new designs. WACO found success with the WACO 9, a fast, maneuverable sport plane that was a joy to fly.

By 1927, WACO factories were producing two airplanes per day—sales were double that of all other competitors combined. Customers waited many months for their planes or paid premiums for a position further up the list. During the 1930s, aviation's golden age, WACO was the world's most successful small aircraft manufacturer. The plane of choice for air-race pilots was often the WACO Taperwing, a short-wing biplane known for its aerobatic qualities. WACO also produced a long line of cabin biplanes for the executive market, continuing the type Orville Wright had introduced with the OW-1. Famous WACO owners included Howard Hughes and Katharine Hepburn. Charles A. Lindbergh worked as a ferry pilot, flying new WACOs from Troy to St. Louis. Many buyers flew to Troy to pick up their new airplanes. The Lollis Hotel gained the nickname "The Waiting for WACO Hotel" because of the many buyers who stayed there.

During the Great Depression, while other manufacturers struggled, WACO thrived by producing rugged, inexpensive aircraft. It enjoyed a large export market, with civilian and military sales to Asia and South America. During World War II, WACO created the famous CG-4A glider, producing 1,074 of the gliders that would land American GIs in France on D-Day. After the War, WACO struggled to find customers, eventually branching into other fields. The last airplane left the factory in 1947, but before going out of business WACO manufactured log-splitters, and even tanning lamps, finally closing its doors for good in 1963. Today, over 400 original WACO aircraft are still registered in flying condition, while a company in Lansing, Michigan, continues to build new WACO YFM biplanes based on the original type certificate.

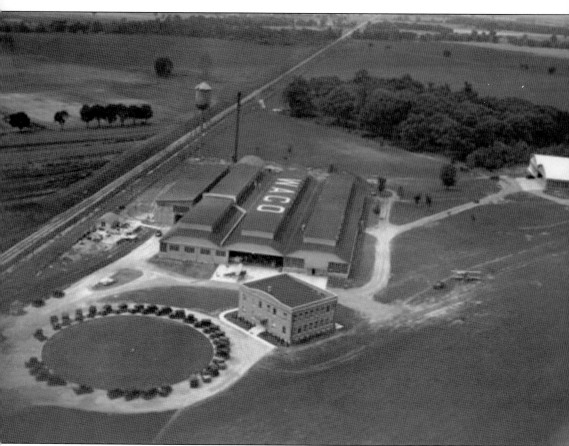

The success of the WACO Model 9 provided the company with enough capital to consolidate production. WACO briefly considered leaving Troy, Ohio, but a 1928 "Keep WACO in Troy" public campaign raised $19,000 to purchase a 120-acre site along High Street and Peters Avenue. In 1930, the name Weaver Aircraft Company was officially changed to WACO, an acronym popular with owners. This 1934 photograph shows the three original factory buildings, with the administration building in the center foreground. In 1942, the wooded area behind the factory was cleared for a new addition, which was larger than all three original buildings combined. It was built for wartime construction of the WACO CG-4A, a troop-carrying assault glider that saw use on D-Day. A total of 1,074 CG-4A and 427 of the larger CG-15A gliders were assembled in Troy before production ended in 1946. Today, the office building is gone, but the factory buildings still stand. As of 2012, the three original factory buildings contain a storage facility, while the larger glider factory is now, fittingly, a B.F. Goodrich Aerospace facility, producing tires and wheels for the aircraft industry. (Courtesy of WACO Historical Society.)

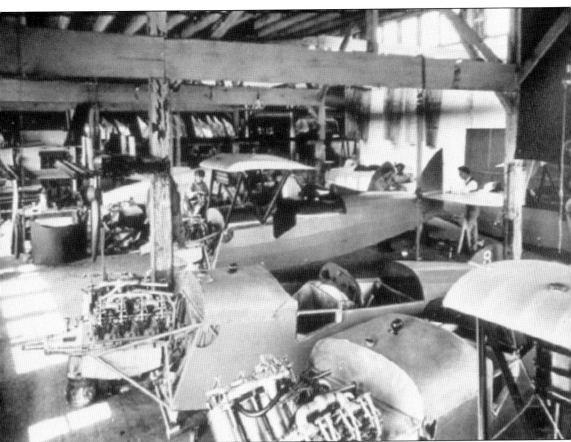

WACO Model 10s are being assembled inside the Peters Avenue factory in this c. 1930 photograph. The success of the Model 9 made this factory possible. Before 1928, WACO's facilities had been spread out over several rented buildings throughout the Troy area. Partially assembled aircraft were often trucked from one site to another during construction. Consolidating production in one location greatly streamlined assembly and reduced costs. Clayton J. Brukner was an expert at cost cutting, often purchasing overstock parts from the auto industry to keep costs down. WACO models were designed to incorporate these bargain parts. Under Brukner's supervision, WACO thrived during the Great Depression, a time when other aircraft companies were struggling. WACO's success in air racing led to numerous military orders, though mostly with South American air forces. Brukner's obsession with cost cutting alienated him from US military contracts. The CG-4A glider was WACO's only big American military order, though the company did supply hundreds of UPF-7 trainers for the country's Civilian Pilot Training Program. In the new factory, WACO was capable of producing two airplanes a day; no other small aircraft manufacturer could produce such quantities. Just like Detroit with the automobile, Troy had become America's small-aircraft production capital. (Courtesy of WACO Historical Society.)

The three-passenger WACO Model 6 was the first airplane the company produced in Troy, Ohio. Like its predecessors, the Model 6 was a World War I–era Curtiss JN-4 "Jenny" trainer, with new wings and fuselage to improve performance. Power came from a 90-horsepower Curtiss OX-5 engine. The Model 6 did not sell well due to the availability of cheap, surplus World War I aircraft. (Courtesy of WACO Historical Society.)

WACO had slightly better success with the Model 7. Like the Model 6, it was a three-seat biplane based on a Curtiss JN-4 "Jenny." Two passengers sat side by side in front, with a pilot seated in the rear. Power, again, came from the Curtiss OX-5 engine. The Model 7 had a revised, smaller tail unit and slightly different wings, giving it superior handling to the Model 6. WACO sold 16 of the Model 7. (Courtesy of WACO Historical Society.)

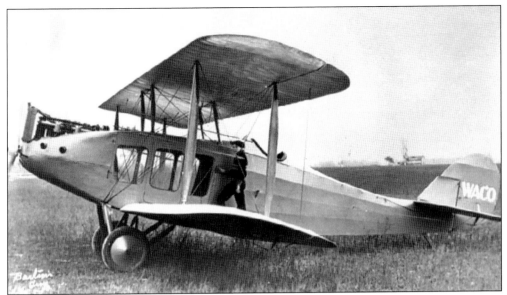

Perhaps the oddest WACO airplane was the Model 8. Produced in 1924, it was the company's first cabin airplane. Intended for the fledgling air-commuter industry, the Model 8 could seat five people in an enclosed cabin behind the engine. The pilot sat in an open cockpit above and behind them. The Model 8 was powered by a 250-horsepower, Hall-Scott Liberty 6 engine, turning a two-bladed propeller. Airlines paid little attention to the Model 8, and the sole example was eventually sold to a company that used it to aerially map the Ozarks. (Courtesy of WACO Historical Society.)

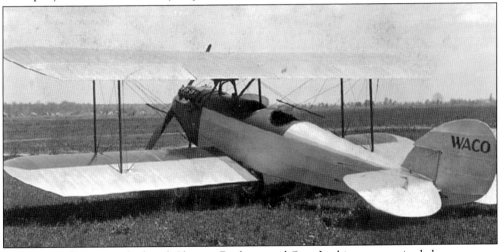

In 1924, Buck Weaver died and Clayton Brukner and Sam Junkins reorganized the company. In 1925, Junkins designed a new aircraft, the Model 9. The "Nine" proved a smash success. Like the Model 7, it was a three-passenger biplane powered by a Curtiss OX-5 engine, but the Nine introduced many new design features that would become common on future WACO aircraft. Starting with the Nine, WACO suspended the radiator under the leading edge of the upper wing. It also featured a new fabric-covered wing and a fuselage strengthened with welded steel tubing. The Nine was strong and reliable, with outstanding performance and handling; 276 were produced between 1925 and 1927. In 1926, fourteen Nines competed in the National Air Races, with several finishing first in their events. Surviving Nines are coveted by collectors, who consider them one of the world's most outstanding biplanes. (Courtesy of WACO Historical Society.)

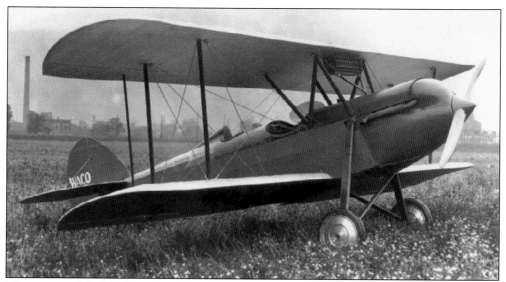

The success of the Model 9 gave WACO the much-needed capital to design a worthy successor. Sam Junkin died in 1926; his last design was the Model 10, which replaced the Model 9 in 1927. The Model 10 was WACO's biggest success. It had a larger cockpit, greater wing area, an adjustable stabilizer, and it was the first small aircraft to feature a shock absorber built into the landing gear. Engine options included the OX-5, OXX-6, Hispano-Suiza, and Wright J-5 Whirlwind. The Model 10 soon became America's most popular small aircraft. 350 WACO 10s with the base OX-5 engine were sold at a bargain price of $2,460. By 1927, more than 40 percent of all small aircraft sold in America were WACO 10s. In 1933, when production ended, 1,623 Model 10s had been built, making it the most-produced WACO model. (Courtesy of WACO Historical Society.)

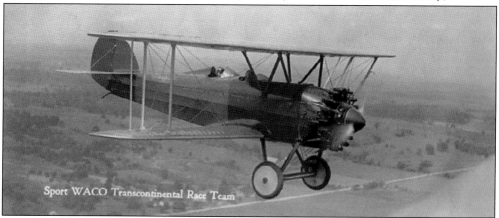

The famous WACO Taperwing was a variation of the Model 10. Designed by WACO test pilot Charlie Meyers for famed air racer Johnny Livingston (who won the 1928 National Air Derby transcontinental race with it), the Taperwing used a smaller wing that tapered near the tips, giving it greater speed and maneuverability. It soon became a favorite of stunt pilots, who devised ever-more-challenging maneuvers to amaze audiences with the Taperwing's agility. WACO test pilot Freddie Lund performed the first outside loop by a civilian pilot while flying a Taperwing. Manufactured from 1927 until 1933, a 1929 Taperwing cost a staggering $7,525 (three times the cost of a regular Model 10). Though less than 100 Taperwings were made (including several for Air Mail service), they remain popular attractions at air shows, with some still performing into the 21st century. (Courtesy of WACO Historical Society.)

Today, the WACO Aircraft Museum continues the WACO legacy in Troy, Ohio. Located at 1865 South County Road 25A, the museum sits on a 70-acre site that includes a 2,000-foot runway for annual fly-in reunions. On October 7, 1997, a historic 1856 barn was relocated to the site; a 7,500-square-foot museum building was finished shortly after that houses the museum's collection of photographs and memorabilia, as well as an educational center with a classroom. In September 2009, a spacious hangar was built to house the museum's collection of vintage WACO aircraft. Construction was made possible through donations from local businesses, as well as a generous grant from the Ohio Cultural Facilities Foundation. (Author's collection.)

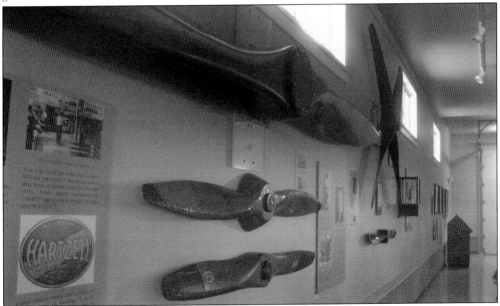

Among the artifacts on display is a collection of wooden propellers manufactured by the Hartzell Propeller Company of nearby Piqua, Ohio. Various two-bladed propellers are exhibited, as well as a four-bladed Liberty propeller. The enormous propeller on top was built for the USS *Shenandoah* (ZR-1), the Navy's first rigid airship. Launched in Lakehurst, New Jersey, on September 4, 1923, the *Shenandoah* used huge custom-built Hartzell propellers. In the early hours of September 3, 1925, it was torn apart by storms near Caldwell, Ohio, killing 14 crew members. Four men were required to lift the *Shenandoah*'s huge propeller onto its display. During the Great Depression, WACO helped keep Hartzell in business, offering only Hartzell propellers to buyers requesting a wooden propeller. In gratitude, Hartzell helped fund construction of the WACO Museum. (Author's collection.)

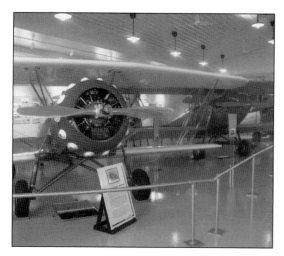

Vintage WACO aircraft at the museum include a 1929 ATO Taperwing NR13918 (s/n A-118). This particular plane was piloted by Lt. Joe Mackey of the Linco Flying Aces from 1932 to 1940. Mackey flew it in the 1936 International Air Games in Paris, France. At the conclusion, he was declared the winner and granted membership in the French Aero Club. The BF Goodrich Corp. restored the aircraft in 1996, and it was flown annually as part of the opening ceremony at EAA AirVenture in Oshkosh, Wisconsin, before being donated to the museum in 2009. Behind the Taperwing is a restored WACO Model 10. (Author's collection.)

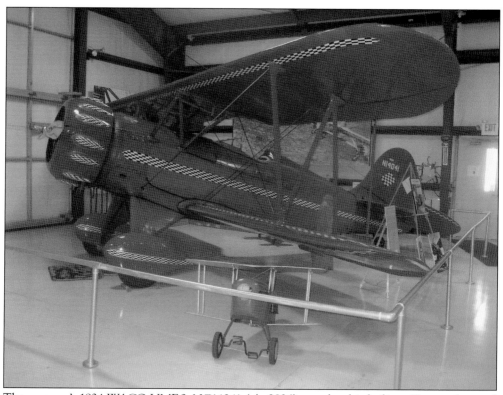

The museum's 1934 WACO UMF-3, NC14041 (s/n 3836) was the third of just 18 manufactured in 1934 and 1935. Intended for affluent sport pilots, it cost $6,530. In 1929, WACO changed its naming system from numbers to a three-letter code, which identified the airplane's fuselage, wing, and engine. The code made identification easy but produced few memorable names. This particular UMF-3 is the world's most flown WACO airplane. After going through a string of owners, it was purchased in 1960 by Dayton pilot Harold Johnson, who fully restored it. Johnson flew it nightly in air shows over King's Island Amusement Park and in an episode of *WKRP in Cincinnati*. It was retired to the museum following Johnson's death with over 14,000 hours on the airframe. (Author's collection.)

Nine

HARTZELL PROPELLER

Hartzell Propeller Inc. of Piqua, Ohio, began in 1917 as a division of the George W. Hartzell Company, a supplier of high-grade walnut lumber to European furniture makers. An embargo imposed by the United States during World War I cut off the company from its customers in England and Germany, and Hartzell was suddenly forced to look for new uses for its walnut in order to survive. The company's president, Robert N. Hartzell, noted the large number of aircraft being manufactured in the Dayton area, and encouraged by his neighbor Orville Wright, he began an ambitious plan to use his walnut to build wooden propellers.

Assisted by a company carpenter, Robert Hartzell first tried using hatchets to chop propellers from solid blocks of wood just as the Wright brothers had done in 1903. The results were unsatisfactory, so the company studied the multi-layer lamination method of other propeller makers. In 1917, the company produced its first propellers for the Glenn-Curtiss JN-4 "Jenny" trainer. Soon, Hartzell Propeller was producing thousands of fixed-pitch wooden propellers for Dayton-Wright and WACO, who were eager to purchase their locally made propellers. In 1919, Hartzell began producing four-bladed wooden propellers for Dayton-Wright's Liberty-powered aircraft. In 1924, the company manufactured huge wooden propellers for the USS *Shenandoah*, the first zeppelin built in the United States. In the 1920s, Hartzell began producing propellers made from duralumin while continuing to manufacture its traditional walnut propellers for WACO, Aeronca, and other small aircraft companies.

Hartzell was a pioneer in the development of variable-pitch propellers and in 1946 developed the first reversible-blade propeller. Hartzell introduced the first practical turboprop propeller in 1961. In 1986, Hartzell manufactured the propellers for Dick Rutan's *Voyager*, the first airplane to fly around the world nonstop. Today, Hartzell Propeller Inc. makes up 85 percent of the world's corporate turboprop market and 60 percent of the turboprop airliner market. Remembering its history, the company generously helped finance the WACO Museum in Troy, Ohio, which has a display of vintage Hartzell propellers.

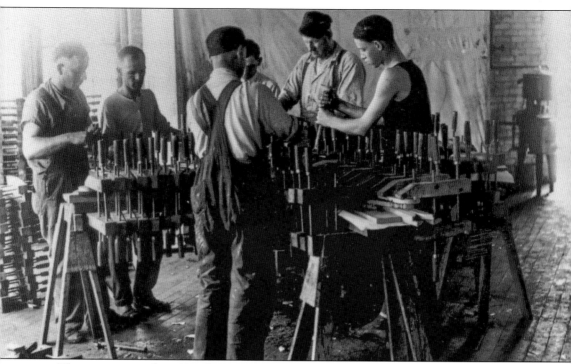

This rare series of c. 1920 photographs shows the methods used by Hartzell to manufacture its early walnut propellers. First, thin blocks are cut from walnut and glued together to form a thicker block made of laminated layers. Carving the propeller from a single block of wood was dangerous, as a single block could hide flaws and imperfections. Orville Wright suffered serious injuries, and his passenger, Lieutenant Selfridge, was killed when a propeller carved from a single piece of wood failed during a flight in 1908. Gluing wood blocks together greatly enhanced the strength of the propeller and minimized imperfections. During the gluing process, pressure was applied using wood clamps. Hundreds of these clamps are seen on the floor in the background. (Courtesy of US Air Force Photo Archives.)

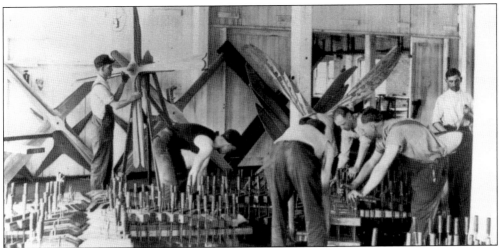

The lamination layers varied in size, with the largest piece in the center, decreasing in size to the front and rear. Varying the size of the laminates reduced sanding time and wood waste. Here, four-bladed Liberty propellers are being glued. The Liberty Propeller was designed for use with Liberty engine–powered aircrafts and was identified by a special decal. The four-bladed propellers seen here were also used on early bombers and other large multi-engine aircraft. (Courtesy of US Air Force Photo Archives.)

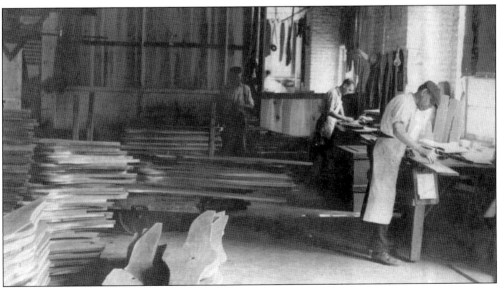

After being glued together, the raw blocks were sent to the Marking Room, where they were inspected for flaws. The weight and balance was also checked here to make sure the unfinished blade was ready for sanding. Some propellers never got further than this stage. If they were flawed or poorly balanced, they were discarded before any more effort was wasted on them. (Courtesy of US Air Force Photo Archives.)

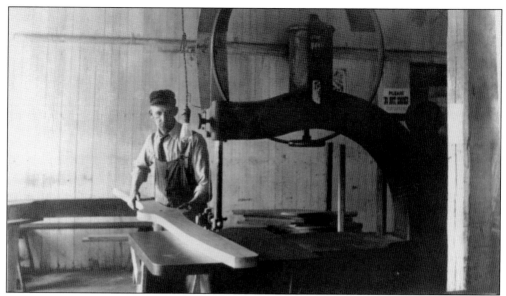

Following inspection, the propellers went to the Cutting Room, where an expert cut the blades to shape using a band saw. This was one of the most difficult steps, as the blades had to be carefully cut into symmetrical shapes. Note that no pattern is used in the cutting; the technician produces the shape from memory and experience. (Courtesy of US Air Force Photo Archives.)

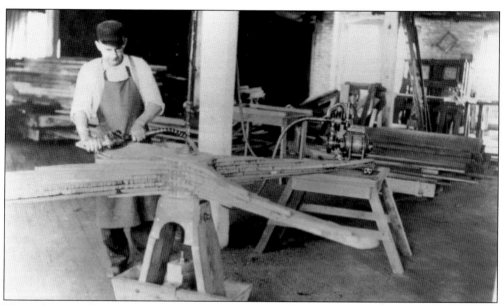

Next, the propellers were roughed using a flexible shaft rougher. Roughing was the first step in attaining the propeller's finished shape. It also exposed the glue to air. After roughing, the glue had to be allowed to set for 10 days in the equalizing room before sanding could begin. This four-blade propeller was made from seven layers of walnut laminate. The decreasing laminate layers are clearly visible. (Courtesy of US Air Force Photo Archives.)

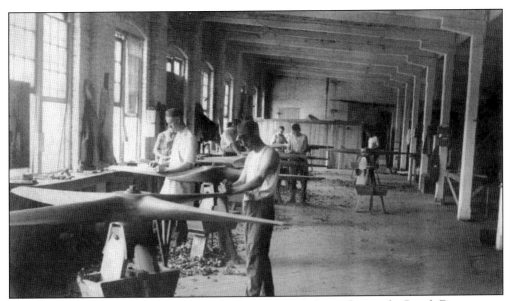

After 10 days in the equalizing room, the propeller was ready for sanding in the Bench Department. Note here that sanding is being done entirely by hand; no power sanders were used. This was a laborious process in which wood was shaved in equal amounts from each blade. The sanding technician had to move from blade to blade, taking care to remove the same amount of wood from each one in order to maintain balance. (Courtesy of US Air Force Photo Archives.)

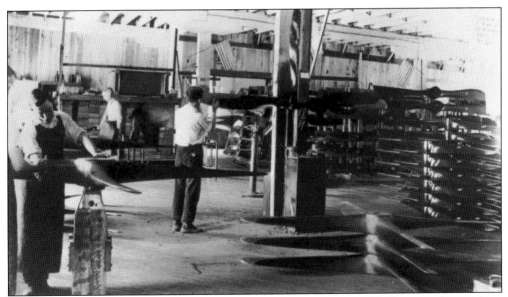

No matter how skilled the technician, the propeller still required final balancing after sanding. This was accomplished by applying layers of varnish at various points on the propeller's surface while it was attached to bearings. The built-up varnish added weight, balancing the blade. The process was similar to the modern method of balancing an automobile tire. (Courtesy of US Air Force Photo Archives.)

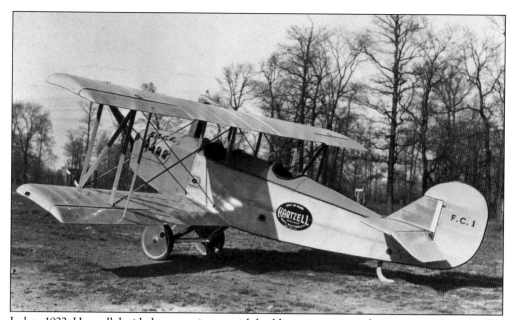

In late 1922, Hartzell decided to experiment with building an entire airplane, not just the propeller. The aircraft was designed by Frederick Charavay, designer of the Liberty propeller. Named for Charavay, it was called the FC-1 (above). The plane was a two-seat, open-cockpit biplane powered by a 90-horsepower Curtiss OX-5 engine. It was the first airplane manufactured out of plywood. To promote its new aircraft, Hartzell hired Walter Lees, a pilot from the Dayton Airport's Johnson Flying Service. Lees piloted the FC-1 in the 1923 International Air Meet in St. Louis, where it placed first in the Flying Club of St. Louis Trophy Race, winning $500. Charavay then removed the wings from the FC-1, replacing them with wings based on the Clark Y airfoil designed by Colonel Clark at McCook Field. Charavay renamed the plane the FC-2 (below), and Hartzell entered it in the National Cash Register Race. The race was held at the 1924 International Air Races at Wilbur Wright Field in Dayton. Once again, Lees flew to victory, winning the Dayton Trophy against a field that included aircraft from WACO and Curtiss. Unfortunately, the defeated competitors were among Hartzell's best customers. Ed Hartzell decided not to jeopardize the success of their propeller line, and after two wins he quietly abandoned the aircraft business. (Both courtesy of US Air Force Photo Archives.)

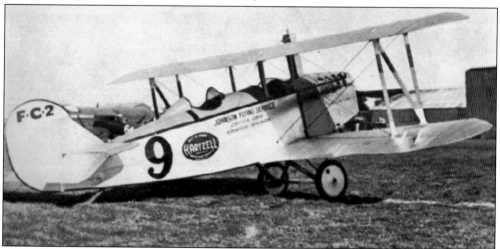

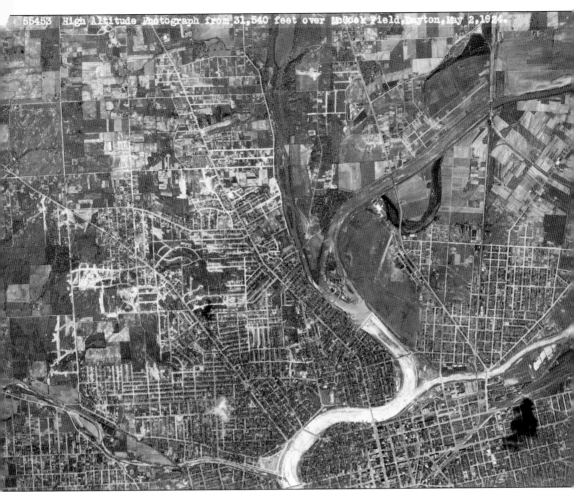

This photograph of Dayton was taken by Capt. Albert M. Stevens on May 2, 1924, from a LePere LUSAC-11 at an altitude of 31,540 feet. Piloted by Lt. John A. Macready, it was the highest-altitude photograph ever taken and the largest area ever covered by a single-lens camera (19 square miles). While director of the Aerial Photographic Branch at McCook Field, Captain Stevens did extensive work on high-altitude aerial photography. He knew that such photographs would not only benefit the military, they would also have great value for civilian work such as surveying, map-making, forestry, and oceanographic research. Steven's work on high-altitude photography paved the way for Cold War spy planes like the U-2 and SR-71, as well as spy satellites. (Courtesy of US Air Force Photo Archives.)

DISCOVER THOUSANDS OF LOCAL HISTORY BOOKS FEATURING MILLIONS OF VINTAGE IMAGES

Arcadia Publishing, the leading local history publisher in the United States, is committed to making history accessible and meaningful through publishing books that celebrate and preserve the heritage of America's people and places.

Find more books like this at
www.arcadiapublishing.com

Search for your hometown history, your old stomping grounds, and even your favorite sports team.